FAIRIES
ART STUDIO

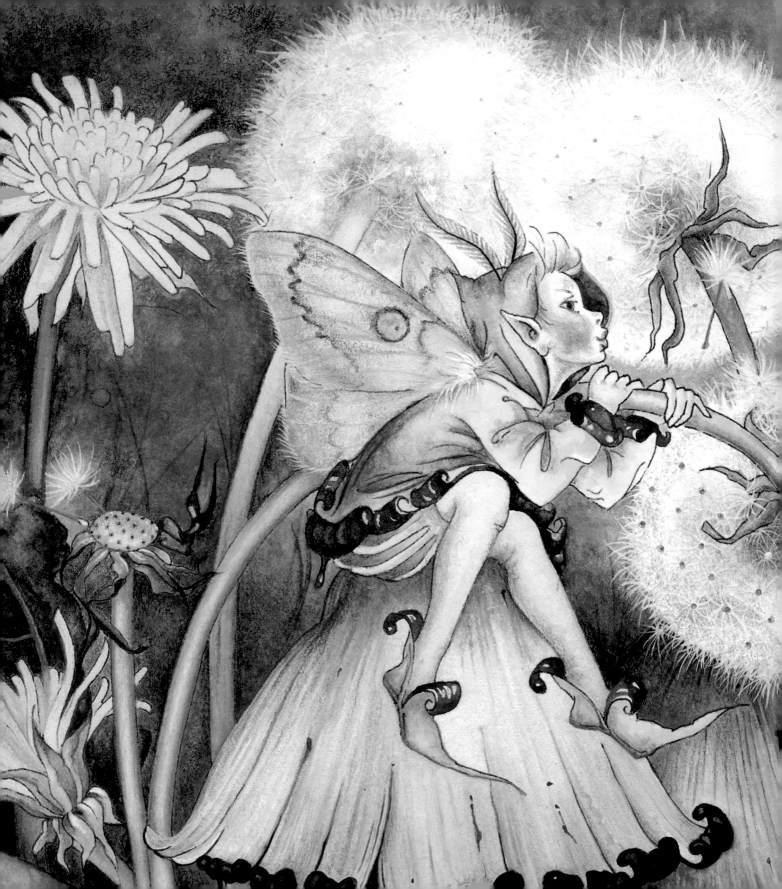

FAIRIES
ART STUDIO

Everything you need to create
your own magical fairy world

DAVID RICHÉ

Featuring artwork
by MYREA PETTIT and
YISHAN LI/YISHAN STUDIO

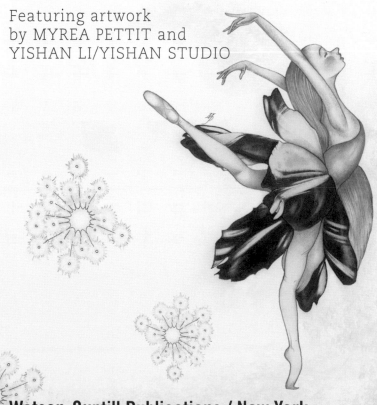

Watson-Guptill Publications / New York

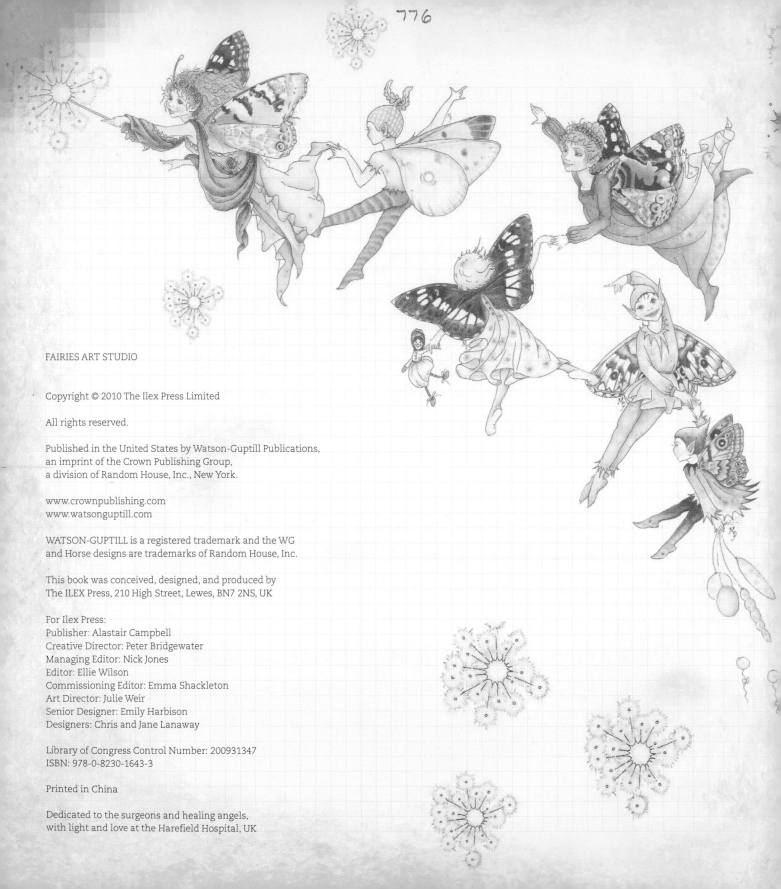

FAIRIES ART STUDIO

Copyright © 2010 The Ilex Press Limited

Published in the United States by Watson-Guptill Publications,
an imprint of the Crown Publishing Group,
a division of Random House, Inc., New York.

www.crownpublishing.com
www.watsonguptill.com

This book was conceived, designed, and produced by
The ILEX Press, 210 High Street, Lewes, BN7 2NS, UK

For Ilex Press:
Publisher: Alastair Campbell
Creative Director: Peter Bridgewater
Managing Editor: Nick Jones
Editor: Ellie Wilson
Commissioning Editor: Emma Shackleton
Art Director: Julie Weir
Senior Designer: Emily Harbison
Designers: Chris and Jane Lanaway

Library of Congress Control Number: 200931347
ISBN: 978-0-8230-1643-3

Printed in China

Dedicated to the surgeons and healing angels,
with light and love at the Harefield Hospital, UK

Contents

Introduction

BRIEF HISTORY

Traditional fairy lore has been passed down through centuries of European and Celtic culture. Childhood memories are filled with enchanting fictional stories that introduce us to a world of beauty from "once upon a time;" with princes, princesses, fairies and fairy godmothers, elves, goblins, and trolls. A world where good fairies and magic spells triumph over fearful witches, dragons, and other frightening creatures, so they live "happily ever after."

However, fairies have not always been depicted as good creatures—at one time they were blamed for illnesses and missing children. They went in and out with a tide of popularity from Chaucer to Shakespeare in the 16th and 17th centuries, until the 1840s when Queen Victoria revived people's appreciation for fairies. English Victorian artists began painting fairy scenes that showed gentle loving spirits of flowers and butterflies—a trend that continued right through to the early 20th century.

The baby boom in the late 1940s saw another growth in fairies' popularity. After two wars and the loss of millions of fighting soldiers, children needed fairy tales and fairy stories once again, and the beauty of nature and creative imagination, synonymous with such tales, flowed with books and cinema, building on a world of fantasy and belief.

The start of the third millennium has also seen a new wave of enthusiasm for fairies in art, in merchandise, and in literature—which is reaching wider audiences through television, web access, animation, fantasy films, and digital greeting cards.

What is a Fairy? What Do They Look Like?

Everyone perceives their own type of individual fairy based on what they were taught as children, influenced by what they may have read and their life experiences. Generally, the image is always caricatured by the addition of wings, maybe a sprinkling of fairy dust, stars, or a magic wand to cast spells or make wishes come true. This wasn't always the case in folklore. Fairies used to ride the backs of birds or a weed called ragwort; it was the Victorians that introduced the wings of insects.

You can study traditional characters of fairyland through the legends passed down over centuries in Norse and Celtic folklore. Fairy—also spelt faery, faerie, or shortened to fae, fay, or wee folk, good folk, enchanted, or fair folk, and other euphemisms—is a type of mythological being or legendary creature in a diminutive human form of spirit. Peace loving and gentle, fairies are often described as metaphysical or supernatural. They live in the Land of Fairy and are closely associated with the elements and natural forces, found among trees and flowers, and creatures of the earth. The oceans have "undines" or mermaids regarded as sea fairies.

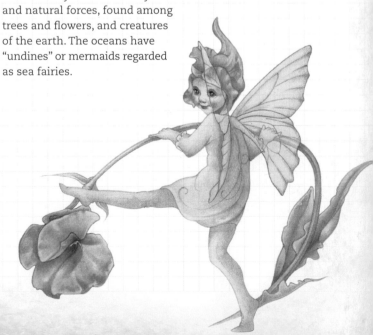

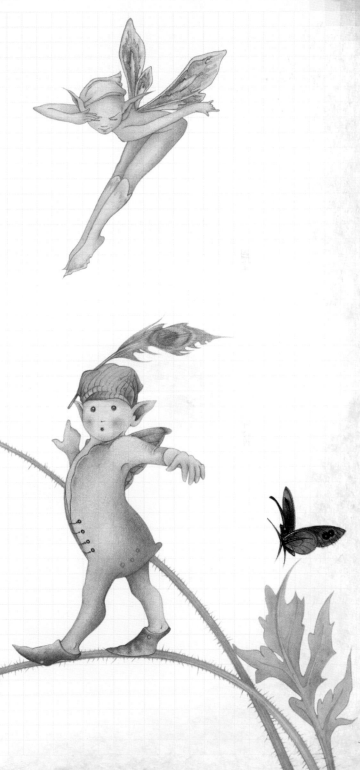

How Do You Draw One if You Have Never Seen One?

There are those that are gifted to sense the metaphysical experience of fairies, and have the skill to put on paper the picture for others to see. These seers are messengers of fairies: authors, artists, poets, musicians, playwrights, who with their interpretations are able to spread the word to help others believe fairies are part of our world.

I asked fairy artist Myrea Pettit, "If you haven't seen a fairy can you possibly draw one?" She told me:

"To be a seer one has to believe, one must believe! As a child I didn't think anything of it, to me this was all a natural phenomena. It was only when older I learned this is the channeling of energy forces, a metaphysical or paranormal experience, and that not only am I blessed with this sensitivity, I have the ability to draw what has spiritually moved me. Fairies do not come to me all the time. On many occasions I have been unable to put pen to paper as the connection is not there. My images within this book are based on the innocence of my childhood experiences and nature surroundings; they originate from the sacred experiences of my personal spiritual journey."

Obviously there are many reading this that do not have those sensitivities. I would encourage you to increase your knowledge of the history of fairies. It will give credibility to your art and awaken your spiritual understanding of fairies.

There are wider interpretations of contemporary fairies; they may have Gothic or dark influences, or wear all manner of fashions. But when creating your own, ask yourself: "Why a fairy?" Who is it for? What is its purpose? Is it to give pleasure, a wish, bring a smile, a touch of beauty to a child, peace to a sick friend maybe, or a blessing?

The idea is to unlock the mysticism and magic of childhood innocence within your artwork. This book and CD will help you to create fairy art, but will also help you to connect with your creativity and imagination.

Believing is seeing!

David Riché, 2009

On the Disc

On the CD there are folders containing a variety of fairy characters, accessories, and backgrounds. Whether you are an experienced fairy artist trying out digital art for the first time, or an all-round computer whizz, or completely new to both, the artwork has been designed so there is something for everyone. The fairy characters are easily created with a few clicks of the mouse and there are countless accessories for those who want to dive straight in and start customizing the characters.

The illustrations can be used as building blocks to create your own fairies, which you can then bring to life with a bit of color. The following section of this book describes professional digital coloring techniques so that you can create your artwork from start to finish on screen, even if you have never used an image-editing program, such as Photoshop, before. Alternatively, you can print out the line-art and use inks, pencils, paints, or pastels to color your fairy artwork.

The characters on CD include traditional fairies, such as sylphs and pixies, as well as more contemporary styles, like manga and gothic fairies. There's also a selection of woodland and forest characters, and of course the usual companions—gnomes, elves, and mischievous puck fairies. Fairy art is about magic and fantasy, and the characters and their worlds are up to you, so let your creativity and imagination go!

Characters
The bulk of the disc is made up of the fairies—24 multilayered character files that can be customized in image-editing programs like Photoshop or Photoshop Elements. By using layers, different elements can be built up to make one of many different character options. Pages 20–25 describe how to create your own fairies, and the Fairies section shows just some of the variations that can be created from each file.

Accessories
There's a selection of accessories included to accompany your fairies or add to your backgrounds. Pages 26–27 have instructions for how to add them to artwork, and in the image gallery on pages 122–123 you can see all the choices.

Plants and Flowers
These work just like the accessory files. You can add them to characters or backgrounds to build up your fairy's world, as seen on page 27, or go straight to the gallery section on page 124–125 to see them laid out.

Backgrounds

There are eight backgrounds to set your fairies against. You can dramatically alter the look of these to create more just by how you color them in. See pages 28–29 for the instructions on how to add characters to them, or pages 112–119 to see them in the gallery.

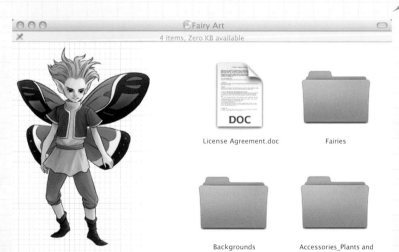

License Agreement.doc Fairies

Backgrounds Accessories_Plants and Flowers

License

You should read this before using any of the files provided on the CD, which outlines the terms for using the images in your own artwork.

Taking it Further

There's no need to stick to just using the elements provided on the CD. As you build up confidence as a digital artist, you may want to start drawing your own fairy line-art characters, or your own outfits and accessories to go with the fairies provided. Alternatively, you might want to scan your own hand drawings into the computer. This package is a useful guide for getting you started, and in time you might want to start creating your own fairy designs from scratch.

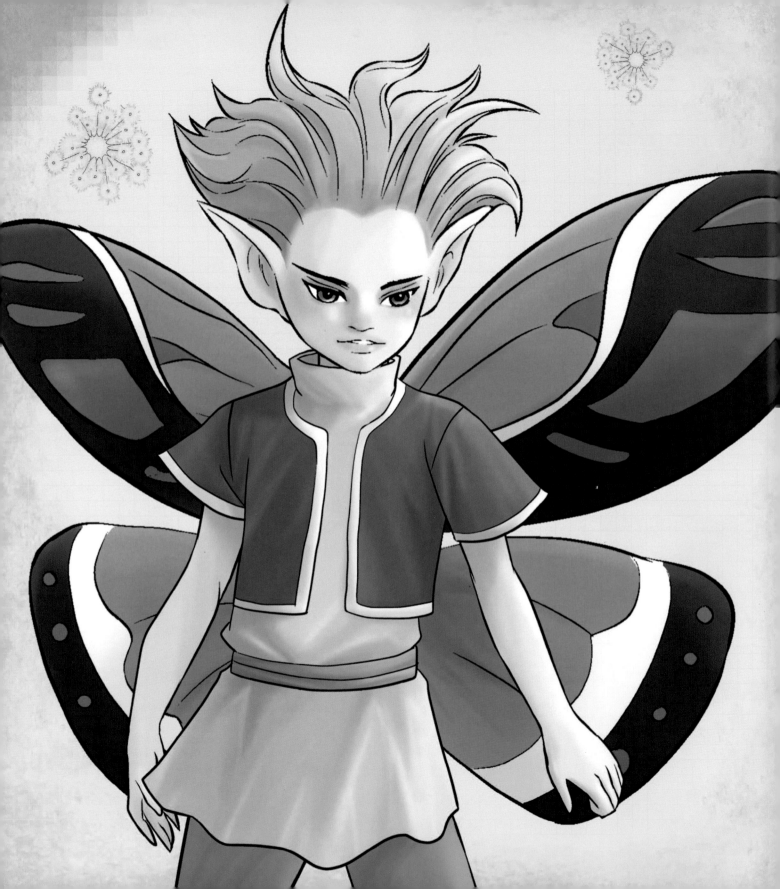

Digital Fairy Art

The digital age has opened up new avenues for fairy artists, who can now create fairy art using just a computer, and publish on the Internet. This section covers how to create beautiful fairies and enchanting worlds—from the basics of using Photoshop's creative software to the techniques of professional digital artists.

Introduction to Digital Art

Art has been revolutionized by the digital age. It is now possible for artists and designers to explore a variety of techniques at the click of a mouse button. A speedy computer and the multitude of creative software available makes the production of professional-quality images far more achievable. With the correct equipment, creating beautiful and fun fairy characters is no longer restricted to professional artists.

Most computers—including the ones shown here—have a variety of functions; storing and editing documents, storing and recording music, editing videos, and most relevant in this case, creating and editing images. The rapid development of image-editing programs means that even complicated procedures have now become relatively simple. If you do not have access to some or all of the equipment shown here, it is possible to acquire these at a reasonably low price. The most popular image-editing software, Photoshop, comes in two packages; as Photoshop and the cut-down version, Photoshop Elements. Elements is the significantly cheaper software and all the processes described in this book can be achieved with this. It has a high range of color options and although they are not as extensive as the full version's CMYK facilities, they are more than adequate for drawing and coloring your fairy images at home.

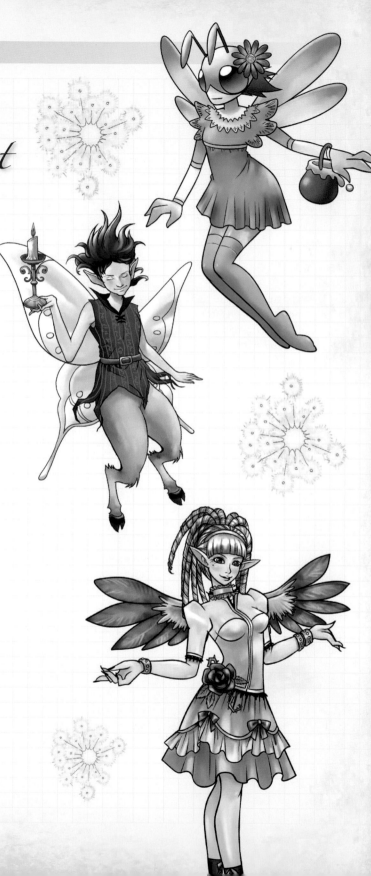

Mouse

All computers come with a standard pointing device called a mouse. However, the quality of your mouse can make all the difference to your work, especially if you intend to do a fair amount of artwork. A laser-or LED-based mouse is preferable to the traditional ball-based mouse. These are far more precise, and they do not jam or get stuck, as they do not require the same amount of cleaning as the ball-based mouse. The only thing to be careful of is the surface on which you use your mouse. Hard or reflective surfaces will bounce the laser back into the mouse and you will find it difficult to move the cursor. Using an opaque mouse mat can easily combat this.

Graphics Tablet

Most designers prefer to use a graphics tablet, and although this might take a little getting used to, it makes it easier to draw and color on a computer. The graphics tablet affords greater control and far more precise movement. Graphics tablets have also been recommended to prevent RSI and cramping from the long-term use of a mouse. When buying a tablet, take into account the type of software that accompanies the tablet and whether the tablet will require batteries. Although the popular graphics tablet brands can be quite expensive, it is generally agreed that the quality and reliability of these justifies the cost.

Inkjet Printer

You can now buy inkjet printers that give you high-quality results for a very low price. A color inkjet printer is certainly worth it in order to see your creations on paper. Using photographic-paper improves the quality of the print if you set the correct options on your printer's software. Keep in mind, however, that colors can look quite different on paper when compared to the color on your monitor. This is especially true of shades of purple, blue, and yellow. Despite the difference though, a color print will still look great!

Laser Printer

The more affordable laser printers are usually only black and white, but they still have some advantages over inkjet printers. Laser printers are quicker and deliver crisper images. The ink from a laser printer is waterproof and resistant to alcohol, significantly reducing the risk of your print being smudged. With a laser print, you can use a marker to color in your images without smudging the ink as is likely to happen with inkjet printers— although with inkjet prints you could always photocopy the image and color in on the photocopied paper.

Internet

Using the Internet makes it much easier for artists to share their work and also access other artists' work. A simple search on the Net will reveal several enthusiasts who share your interests and this can often be a great learning tool.

You can safely publish your work on the Net and even have it protected by copyright against piracy. The exposure will earn you valuable feedback, support, and advice on improving your skills. Interacting with other artists can be

inspiring, and you too could inspire others. Being aware of the possibilities that the Internet affords you can help you share your work with the many fairy art enthusiasts who will be able to appreciate it.

Photoshop and Photoshop Elements

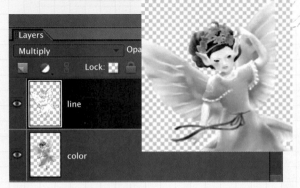

Though there are several image-editing software packages available to digital artists, Photoshop is the software of choice for most professionals. The wide selection of tools available in Photoshop makes it great, not just for editing photographs, but also for illustrations and drawings. With Photoshop you can create beautiful fairy images from scratch and the software supports very high-resolution files, thereby giving you the best possible quality should you decide to print your images. As mentioned on the previous pages, Photoshop comes in two versions. The full version is part of Adobe's Creative Suite, while Photoshop Elements is the cheaper version with a smaller selection of the key image-editing tools. The main features outlined here are available in both versions of Photoshop, but all the examples in this book have been created in Photoshop Elements to demonstrate the quality and scope of even this pared-down version of the main software.

Layers

One of the most crucial aspects of digital imaging is the use of layers. Imagine each layer as a piece of transparent acetate with one section of a picture drawn on it. The entire picture becomes visible when all the layers are stacked together, but you can work on each layer separately without altering the rest of the picture. Turning layers on and off allows you to create different options for the same image. An eye logo indicates that the layer is visible, or "on." You can experiment using the layers you prefer and have fun switching your fairy images around.

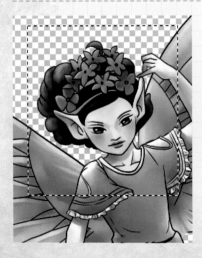

Selection Areas

Aside from using layers to control which part of the picture you are working on, you can further restrict the area of the picture you are affecting by using the selection tools. A perforated line or "marching ants" appears around the selection and changes can only be made within this area. This stops you from accidentally coloring your whole image red when you only meant to touch up a flower. You can also decide what shape you want your selection to be. For example, the selection can be square or round, which helps you work around the shapes in your picture. The Rectangular Selection tool draws a simple box, while the Magic Wand tool cleverly selects areas of any shape of a similar color. Simply "deselect" the selection tool when you're finished.

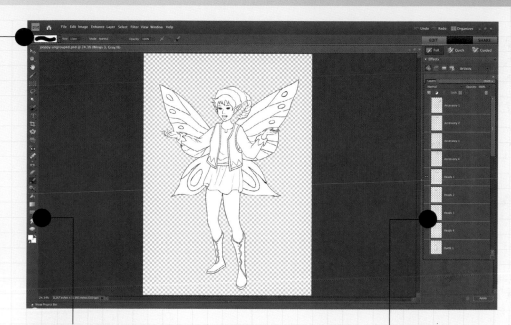

Tool Options Bar

The Tool Options bar appears at the top of the screen and supports the Toolbox. After selecting a tool from the Toolbox, you can refine the tool with the Tool Options bar. If you are using the Eraser tool, for example, you can set the size of the eraser using the menu on the Tool Options bar. Similarly, you can adjust the size, thickness, and texture of your brush when using the Brush tool.

Toolbox

In both versions of Photoshop, the Toolbox appears by default on the left hand side of the screen. While Elements has a slightly different Toolbox from the full version of Photoshop, they both contain the key tools you will use while editing your fairy images.

Palettes

The term "palettes" refers to the many floating windows that appear on your screen while using Photoshop. These can be switched on or off using the Window option at the top of your menu bar. You can also move these palettes about to suit you depending on how you use them. If you need to frequently switch layers on your Layers palette, you can bring this palette closer to the image, thereby reducing how far you have to move the mouse each time.

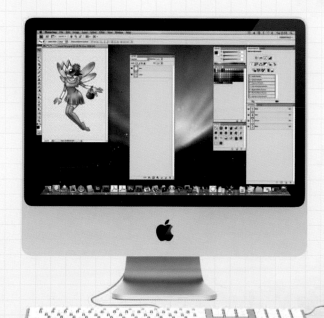

Here, Adobe Photoshop CS4 is shown running on an Apple iMac. The larger your computer monitor, the more room you will have for palettes. You can also zoom into your image to make it as large as your monitor, but remember to always check your artwork at 100 percent. This is because it is only at this size that the pixels in the image are seen at a ratio of 1:1 with the pixels on your monitor. Checking your image at other sizes will give you a less accurate impression.

Photoshop Tools

Regardless of which version of Photoshop you use, the Toolbox contains all the key functions you need to create your own digital fairy artwork. The Toolbox enables you to zoom in and out of the image, move parts of your image around, and add accessories, until the picture is just right. The Toolbox also contains all the elements you need to color in and shade your artwork.

Navigation

Moving around your image quickly and easily is an important part of digital art. You will need to zoom in and out, scroll to a different part of the image, and focus on small details. Quick navigation helps you to work more efficiently.

Navigator Window

You can access the Navigator window by clicking on the Window tab at the top of the menu bar. This window enables you to move quickly around your document without having to use the Toolbox or keyboard. This can be an added bonus when using a graphics tablet and if you prefer to avoid using the keyboard.

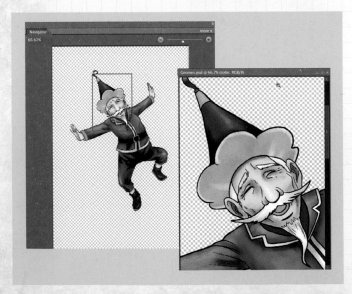

Navigation Tools

Move
Click and drag to move the currently active layer or selection.

Zoom
The Zoom option allows you to magnify or shrink your image, if you want to focus on small details or zoom out to look at the bigger picture. A keyboard shortcut for the Zoom tool is Ctrl/Cmd and the + or – keys, (+ enlarges the image and – reduces it).

Hand
The Hand tool is used to scroll around the image enabling different parts of the image to be the main focus on your screen.

Eyedropper
The Eyedropper tool is useful when coloring your image. Use this to select any color you want and this will become the foreground color at the foot of the Toolbox. You can also use this to duplicate color from one part of your image to another. Make sure to set the mode to "point sample" to ensure precise color picking. When using the Brush tool, pressing the Alt key has the same effect.

Terminology

Occassionally this book will mention keyboard shortcuts that can save time. While the letter is usually the same, control keys vary between Windows and Macs, so Ctrl/Cmd + C means hold the key marked Ctrl and tap C on Windows, but for a Mac use the key Cmd and tap C.

Selection Tools

Paint Tools

Selection

Being able to select the exact part of an image you want to work on is crucial. Photoshop has a variety of selection tools to help you do this.

 Marquee Tool

The Marquee tool is the basic selection tool and highlights a simple rectangle or elliptical shape. Click and drag to select an area. Holding down Shift creates either a perfect square or circle.

 Lasso Tools

These tools create any shape you like, even irregular ones. The Freehand Lasso creates a shape you draw with your mouse, but it can be difficult to be precise with a mouse. The Polygonal Lasso draws a series of points to define a shape.

 Selection Brush

The Selection Brush is exclusive to Photoshop Elements and enables you to "paint" the selection onto the image. You can use this to fine tune selections you have made using other tools. Photoshop has the Quick Mask feature that uses other tools to "paint" the mask instead.

 Magic Wand

The Magic Wand tool selects areas of a specific color. Holding down the Shift key allows you to select multiple areas of the same color.

Paint Tools

These tools are used to draw lines and add color to an image. The brushes come in different shapes, sizes, and thicknesses, and these affect how the lines appear. Page 18 discusses Photoshop brushes in greater detail.

 Pencil

The Pencil is a variation of the Brush tool and creates pixel perfect or "aliased" lines. This is useful when trying to keep the coloring sharp since the computer tends to soften edges by default.

 Paintbrush

This is the basic paint tool and is ideal for drawing in smooth lines and soft edges. It is possible to experiment with a variety of brush styles using the Tool Options bar.

 Paint Bucket

The Paint Bucket fills in a particular area with a selected color. This is useful when laying down block colors prior to shading and also when filling in color in large areas. The tool will fill in color in any closed selection, and you can adjust the level of contrast to define the edges using the "Tolerance" tab at the top of the Tool options bar.

 Eraser

The Eraser works just like the Paintbrush but removes color instead of adding it. Use this to delete color or erase lines from a layer.

 Dodge, Burn, and Sponge

These tools work like brushes but adjust the color on the image. Dodge lightens the color, Burn makes it darker, and Sponge absorbs it, leaving the area gray. These can be useful for shading, if you are not using separate shading layers.

 Smudge, Blur, and Sharpen

These three tools do not have any color of their own but adjust the existing color(s). Smudge smudges the color in whichever direction you move the cursor, Blur dulls the contrast of the neighboring pixels, and Sharpen increases the definition of the pixels to make the image sharper.

TIP

If you hold the Shift key down when using the selection tool, you will be able to make more than one selection at a time, which can be treated as a single selection. Holding the Alt key allows you to delete areas from the selection. The + and – signs by the cursor show if you are adding to the selection or subtracting.

 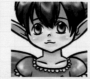

Dodge Burn Sponge Smudge Blur Sharpen

Photoshop Brushes

When you begin to draw your own fairy images or even while editing some of the images on the CD accompanying this book, the two most useful tools will be the Brush and Pencil tools. They are the standard method for adding color and drawing lines. The Brush settings can be adjusted to give you exactly the effect you want. The color from your brush can be opaque or translucent. The nib can be sharp or blunt, and can vary in size and width. It's a good idea to learn how to control these settings so that you are able to get the full use of the brushes available in Photoshop.

Brush Shapes

 Hard Brush
Use these brushes to get a solid shape and smooth outline. Even with an anti-aliased (softened) edge, the brush is still sharp enough to produce a convincingly hard line.

 Soft Round
Soft round brushes have a gradient of density and the opacity reduces towards the edges. These brushes are useful for soft and airbrush style coloring.

 Natural Brushes
In order to recreate the effects found in "natural media" such as paints, pastel, and charcoal, Photoshop has a selection of irregularly shaped brushes. This is useful when trying to create effects that look very similar to painting on canvas or paper.

Brush
This menu allows you to choose from the vast array of brushes. You can cycle through these options using the < and > keys.

Size
Once you have chosen a brush, decide what size you would like to use. The [and] keys can be used to change sizes.

Airbrush
Using the brush in Airbrush mode allows a gradual flow of paint. The flow can be adjusted using the Flow setting. Though this is a useful tool, you can simply use a soft brush instead.

Opacity
Adjusting the opacity determines how transparent or opaque the paint will be. This is also a useful tool if you want to see through layers to adjust the layer beneath. The paint is completely solid at 100% opacity, semi-transparent at 50% opacity, and invisible at 0%.

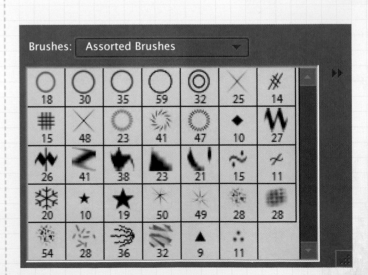

Brush Spacing

This simple setting in the Brushes palette makes a big difference to the quality of your lines and also to the performance of your computer. Reducing the brush spacing causes the dots to be drawn closer together, and in most cases this can result in a smoother line, while translucent areas of the brush appear darker. The more dots you draw, however, the harder your computer has to work. Increasing the brush spacing is very important when using a graphics tablet; this avoids the line breaking when the pen is moved very quickly.

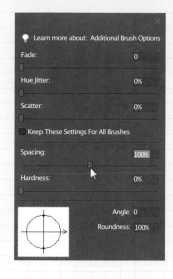

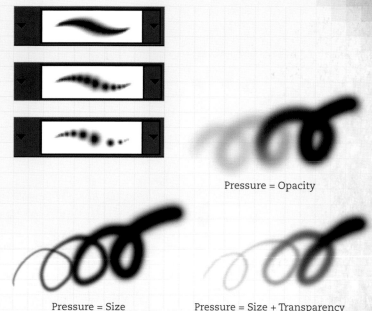

Pressure = Opacity

Pressure = Size

Pressure = Size + Transparency

KEYBOARD SHORTCUTS

Quick Brush Resizing

You can use the square bracket [and] keys to quickly resize the brush. If you hold down the Shift key at the same time, this alters the hardness of the brush. This is a useful tool when using soft brushes to color your images and helps you to quickly adjust the level of the detail you are working on.

Quick Color Changes

When using the Brush and Pencil tools, you will often want to change between colors quickly without reopening the color picker tool each time. Hold down the Alt key and click on the color you want on your canvas. You can even create a "palette" of dabs to keep on your screen until you have finished working. Using the X button quickly switches between foreground and background color.

Painting with Opacity Controls

Use the number keys at the top of your keyboard as shortcuts to adjust your brush opacity. Pressing 1 gives you 10% opacity, 2 gives you 20% opacity, and so on. If you press 3 and 5 very quickly, you will get 35% opacity. Adjusting the opacity is a good way to add subtle effects to your coloring without changing the color. Combined with the X button shortcut, it allows you to create monochrome illustrations very quickly!

Graphic Tablet Pressure Settings

Unlike a mouse, the pen on a graphics tablet is pressure sensitive and this gives you even greater control over the Photoshop tools. Just like using a real pen, the pressure you put on the tablet pen adjusts the stroke of your brush tool on the screen. When drawing inks and blocking in color, it is usually best to set the pressure control to Size and then set it to Opacity when adding color or shading. The more expensive graphics tablets like the Wacom Intuos series also recognize pen tilting, and this means that additional settings can be adjusted depending on how the pen is being held, whether vertical or at a slant.

Creating Fairies

Creating a fairy character from the files supplied on the CD is easy and fun! There are myriad variations to experiment with and creating different combinations can give you surprising results. The files here are very flexible so you can mix and match layers from all over in order to create your own customized fairy.

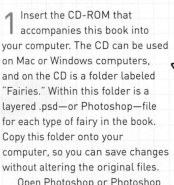

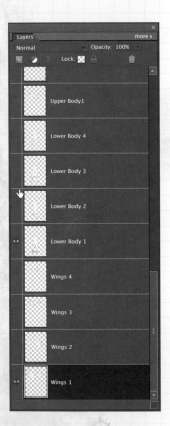

1 Insert the CD-ROM that accompanies this book into your computer. The CD can be used on Mac or Windows computers, and on the CD is a folder labeled "Fairies." Within this folder is a layered .psd—or Photoshop—file for each type of fairy in the book. Copy this folder onto your computer, so you can save changes without altering the original files.

Open Photoshop or Photoshop Elements on your computer and go to File > Open and choose the characters you want to work with.

The layers on the file work in the same way as a transparent acetate, with each layer drawn separately. When layers are combined, they give you a complete picture. The layers on these files also act as image options, with three or four different types of limbs, heads, and outfits for each character. All you need to do is put together the elements you like best to create a fairy character.

You can do this by turning the visibility of layers on and off by clicking on the eye icon just to the left of the layer on the Layers palette.

2 You can turn to the later pages in this book to see some other options for each character. There is also a complete listing of all the layers available to you. Generally, you will not want to turn on more than one layer for the head, torso, and limbs.

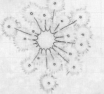

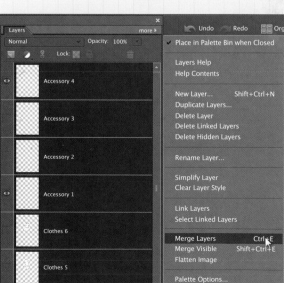

Merge Layers

Merging layers can be necessary if transferring one image to combine it with another. Make sure all the layers are selected and click More > Merge Layers at the top of the Layers palette. You can also select all the layers and press Ctrl/Cmd and E.

3 When you have finished creating a character you like, select the layers and "merge" them together into one single layer. Remember you can still go to your original file to create variations of your character. Save the image on your computer using File > Save As from the menu. (Remember to click Save As and not Save, as Save will overwrite the original file, whereas Save As creates a new file out of the work you have done.) There are some more tips on the next few pages that help you adjust the image so that each layer fits perfectly and your fairy can be just right.

Adjusting the Layers

It is possible to change the look of the character and outfits simply by adjusting the layer order.

Simply drag the layer you want to switch up or down on the Layers palette.

In the example here, two outfit layers have been switched on, Outfit 1 and Outfit 7.

In the first image, Outfit 7 is below Outfit 1 and adds an extra texture beneath the fairy's dress. In the second image, Outfit 7 has been moved above Outfit 1 to create a different look.

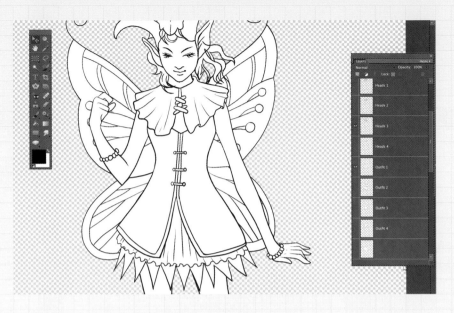

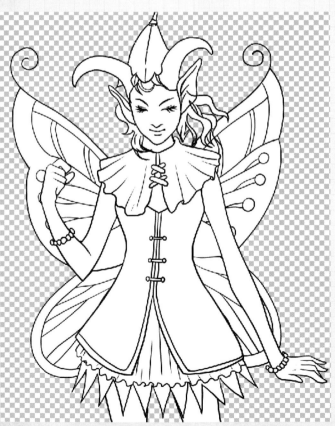

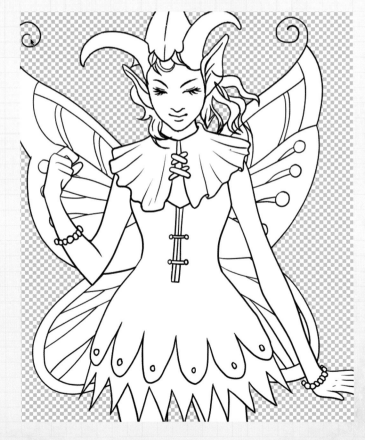

Additional Clothing

Aside from adjusting the layers, you can also change the appearance of the fairies' clothes by drawing and erasing a few lines. A simple line across an arm could suggest a sleeve or a cuff, and if you think about how you want to color your fairy then you can add and subtract lines with this in mind.

Here are some options to try:
- Stockings
- Leggings
- Long socks
- Ankle socks
- Sleeves
- Gloves
- Collars and chokers
- Straps

Original

Leggings

Ankle Socks

Bodysuit

Original

Sleeves

Straps

Although simple, erasing lines can be very effective. In the example here a dress has been added to the outfit of the gnome. You can see that it doesn't fit quite right, so the upper half of the dress has been erased so that it appears to be under the gnome's jacket. It now looks like it is part of the gnome's outfit.

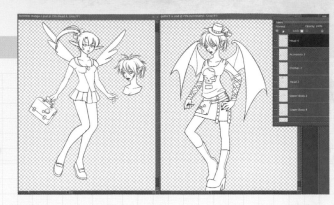

Mixing Fairy Costume Sets

It is possible to experiment with many of the different costume sets combining elements from different characters rather than just the layers on one file. By interchanging outfits, wings, and accessories, and even faces and body parts, you can completely customize your fairies giving them unique appearances.

Contemporary Fairy

Gothic Fairy

2a Select the layer you want to use. You can copy it by clicking on the layer in the Layers palette and dragging it across to the other image. Alternatively, you can click on the layer you want,

press Ctrl/Cmd + C and then Ctrl/Cmd + V on the image you want to transfer the layer to. If you copy and paste the layer using the Ctrl/Cmd keys, the layer appears automatically in the Layers palette.

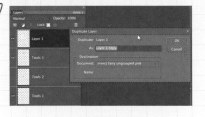

2b A third method is to right click on the layer or go to the Layer menu at the top of the Menu bar and then click "Duplicate Layer." Choose the destination image from the scroll down bar and you can transfer the layer.

1 First select the files you want to mix. This might take a little trial and error as some costumes sets mix together better than others. If you are using Photoshop Elements, open both or more files and they will appear in your Project Bin at the bottom of your screen. You can use this to switch between the files you want.

3 The head from the Gothic fairy has been added to the Contemporary fairy, by flipping the image and nudging it into position. Both techniques are explained on the next page.

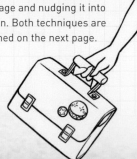

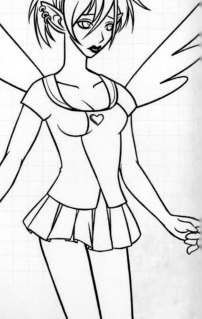

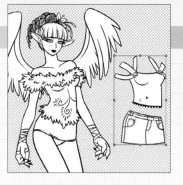

Not all components fit each other perfectly and will need to be adjusted and tweaked to be harmonious with your image. You can do this by using the techniques described here.

Rotating or Resizing

Rotating and resizing elements like accessories, heads, and limbs can alter the appearance of your fairy, and will be useful when mixing elements from different fairy sets together. This is achieved by using the Free Transform tool, available in both versions of Photoshop.

To bring up the Free Transform tool, first select the layer you plan to adjust on the Layers palette, then go to Edit > Free Transform. The keyboard shortcut for this is simply pressing the Ctrl/Cmd + T keys. A box will appear around the selected layer.

To rotate the image, hover your mouse over the corner of the box and the cursor will change to a curved, two-sided arrow. Simply click and drag in whichever direction you wish to rotate the image. If you are happy with the position, press Return or the green arrow at the bottom (or the red circle to undo the rotation). If you want to move the object a bit, click inside the box and drag it to the right spot.

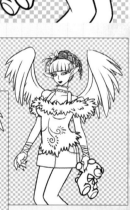

Nudging Into Position

If elements of your images do not line up together perfectly, you can nudge these into position using the Move tool from the Toolbox. Drag the image until you are happy with the new position or move it along using the arrow keys on your keyboard. Here a Gothic fairy has been combined with a Contemporary Manga Female fairy. The clothes have been resized, rotated, and moved to fit the Gothic fairy. The teddy bear has been added from a Child fairy and resized to fit in the hand of the Gothic fairy.

To resize the image, hover your pointer at either the corners of the box or at the center points on the sides of the box. The cursor will turn into a double-sided straight arrow and you can resize the image by dragging the box to become larger or smaller. You can maintain the scale of proportional width and height of the object by holding down the Shift button. It is better to use the arrows at the corner to resize images, as the arrows on the side only stretch the image and don't resize proportionally. Press the Return key to confirm the new size, or click on the green arrow.

Flipping

Flipping your image can give your picture a different perspective. You can do this to the image before or after coloring and can be useful when placing images against a background. You can flip the whole image or even one single layer if you want to add an accessory from another character. Click Image > Rotate > Flip Horizontal.

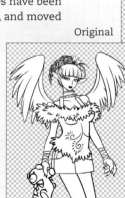
Original

Flipped horizontally

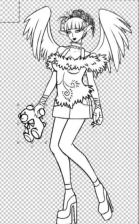

Single layer (teddy) flipped horizontally

Adding Accessories

You can add accessories to your fairy in a number of ways. The simplest is to turn the accessories layers on the file on and off. If you want a few more options you can drag across accessories from the other fairy files, or you can choose from the many options in the Accessories folder on the CD. Open your chosen file and drag the accessory across to your fairy.

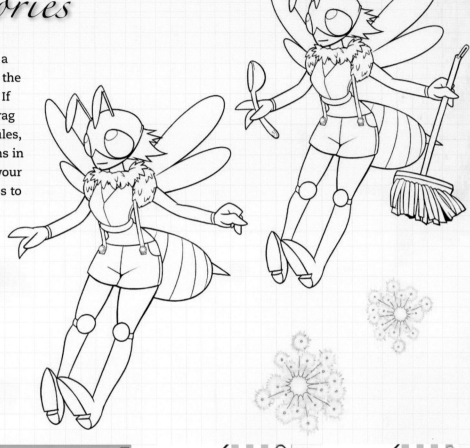

If necessary, resize and rotate the accessory to fit your character. You might also have to drag the accessory layer up or down the Layers palette to position the accessory behind or in front of the character.

Another trick to make an accessory fit your character exactly, is to reduce the opacity and use the Eraser.

First resize and position the accessory exactly how you want it.

Then reduce the opacity of the accessory layer. About 40%–50% should enable you to see enough of the accessory and the layer below so that you will know which lines to erase.

Zoom in as close as possible to avoid any errors and make sure your work is neat and precise. Erase the sections you want using the Eraser tool at a size that is convenient and ensures neat results.

When you are done, restore the opacity to 100%. In the example here, this Insect fairy has been given accessories from a Garden fairy and the lines have been erased so that it appears that the fairy's thumbs are "above" the broom and spoon handles.

As well as the Accessory files, there are also Plant and Flower files for placing your fairies in nature. You can add these to your fairies the same way you would an accesory, or an element from another fairy set.

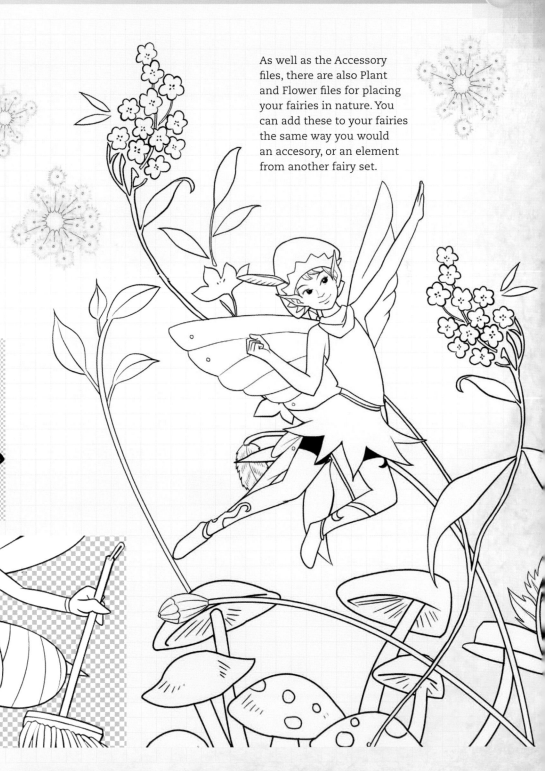

Adding Characters to Backgrounds

The process of adding characters to backgrounds works the same way as you would add accessories to characters. You will need to merge all your layers and then drag the image layer to the background file. To merge your layers, highlight the layers and select "Merge" from the Options menu. The keyboard shortcut for this Ctrl/Cmd + E.

Resize your fairies to fit the background and experiment with placing them in different spots. Add as many fairies as you like, mixing and matching from different groups.

In the example here, the Puck fairies have been made to appear as if they are sitting on the furniture, while the Chibi and Insect fairies fly around the room.

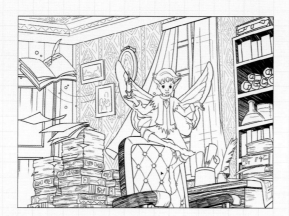

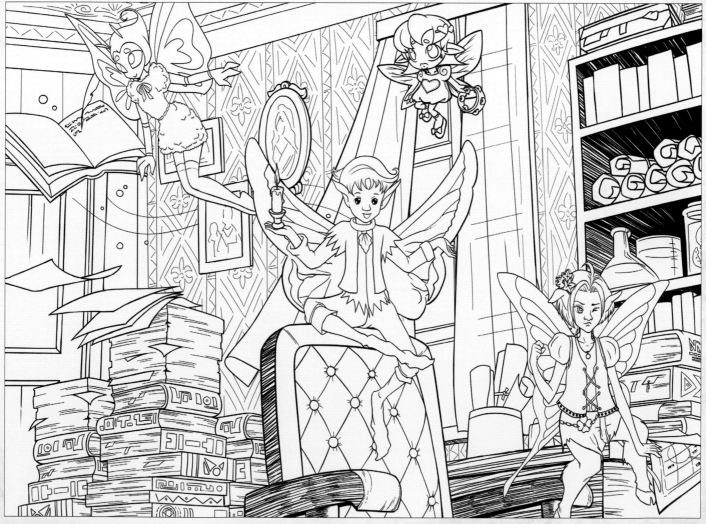

Choosing Colors

Regardless of how attractive the line-art that you have created is, choosing the wrong colors can ruin your hard work. How you choose to color your image can determine the overall impact, and changing something as simple as skin tone or hair can completely alter the look of your fairies. Choosing the right colors is crucial to creating beautiful, professional-looking images.

It helps to decide a few things before you begin to color your image. Do you want to use colors that are realistic or do you prefer to block in colors so that the image looks more animated and cartoon-like? The advantage is that since you are working with fairies, any number of combinations can work without seeming too outlandish. Fantastical creatures can have sparkling green hair and it will not look at all out of place.

Before you begin to color your image, it is helpful to know a little bit of the theory behind the color process and which colors naturally work well together. The way you use color can have the effect of evoking thought or implying a message beyond the image itself. Coloring an outfit in red, white, and blue can subtly suggest American, British, or French nationality. Color is also used to convey mood and emotion.

Red, orange, and yellow are seen as warm colors. They can be used to suggest danger, heat, and even passion. These colors are traditionally associated with the colors of the sun and depending on how they are used can convey a peaceful sunset scene or a deadly blaze in a forest. But these colors used separately can also have a different appearance. Yellow teamed with light and pastel shades or even on its own gives a strong impression of a light,

summery feel. It is the color of many flowers and fruit and can be used to particularly evoke the sense of being relaxed and footloose. Red on the other hand is used to color warning signs and indicates danger.

Blue, green, and purple are the opposite and are generally thought of as cool colors. These are often used as soothing colors, primarily because of how they are represented in nature. Blue reminds us of the sky or the sea, while green reminds us of forests, leaves, and trees. Purple is more of an eccentric color and is used to denote nobility or even spirituality. Blue and green have negative connotations as well. Green is the color of envy and jealousy. Blue can be a cold color used to convey depression and gloominess.

Gray, beige, and brown are neutral colors and create subtle toned down images. In clothing they can represent a sober professional appearance but are usually most effective when teamed with more vibrant colors.

Design

The color schemes you pick will go a long way in giving your work a unique edge. You might want some of your fairies to be dressed quite realistically with modern outfits and so you might use more subtle colors that do not clash too much. However, you might feel that the enchanted fairies need to

look out of the ordinary, and so you will want to try something a bit different. Don't allow yourself to be held back by conventional color schemes; experiment with different shades of the same color and see the effects you can get with just a little shading. The best way to know what you want is through trial and error, so don't be afraid to try!

The Three Golden Rules of Coloring
Research

If you do decide you want your fairy to look realistic, think about your background and research what colors have traditionally been used. Make sure your colors suit the genre of your image.

Design

Keeping an element of design present in your coloring is an important skill. If your fairy is wearing a sparkling blue cap, maybe the socks or bracelets can be colored to match this. The consistency will show that you have put careful thought into your fairy's appearance and will give your image that professional edge.

Have Fun!

Most importantly, play around and experiment with your project. The information here is just a starting point and your creativity will do the rest. Coloring can be a long process, but be patient and the results will be very rewarding.

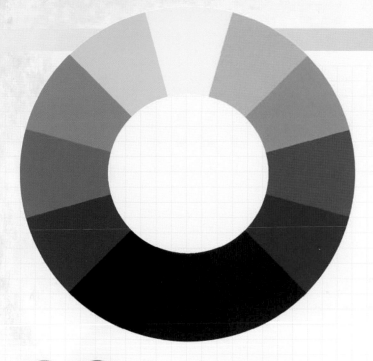

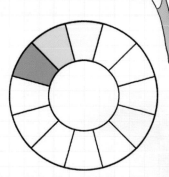

Primary Colors

Though it is popularly believed that the primary colors are red, blue, and yellow, a more accurate view sees primary colors as cyan, magenta, and yellow. A combination of any of these colors can create any color in the spectrum.

Tertiary Colors

The tertiary colors are yellow-orange, red-orange, red-purple, blue-purple, blue-green, and yellow-green. Tertiary colors are made by mixing a primary color with a secondary color.

Placing all these colors in a color wheel gives you a quick overview of the basic colors and which can be combined with the others.

Secondary Colors

Secondary colors are made by mixing the primary colors together. The secondary colors are orange—a mixture of magenta and yellow; purple—a mix of magenta and cyan; and green—made by mixing yellow and cyan.

Analogous Colors

Colors that are close together on the color wheel are known as analogous. Choosing these will give you colors that relate to each other and create a subtle color scheme.

Complementary Colors

These are colors that appear directly opposite each other on the color wheel. Choosing complementary colors creates a vibrant image with strong contrasts. Be careful to combine bright colors with subtle ones or your image could become too garish.

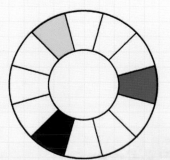

Triadic Colors

The concept behind a triadic color scheme is to choose three colors that are evenly spaced on the color wheel. It is a good idea to first pick your two basic colors and use the third as an occasional highlighting color to add depth and accents. This is an effective color scheme because the third color will be equally different from each of the base colors.

Blocking in Base Colors

Once you have finished creating a fairy and decided on an appropriate color scheme, it is time to block in the base colors. This is the most important first step of coloring and will be the time when you pick the dominant color you plan to use in your image. What is the effect you want your picture to have? Do you feel your picture would look better with soft, pale colors or strong, bold effects? Choosing your colors carefully now will affect the colors you choose for shading and highlights, and will form the foundation of your entire image. A good color scheme can, in some cases, be all that the picture needs in order to look complete.

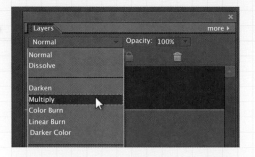

3 To prepare the line-art, copy it to a new layer and set this layer's blend mode to Multiply. This means that the colors on the layers beneath will show through the layer above.

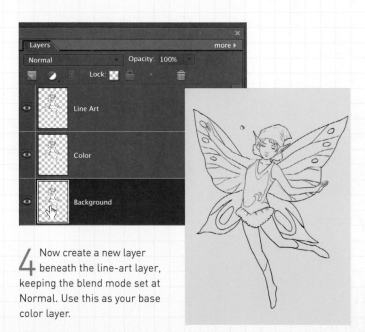

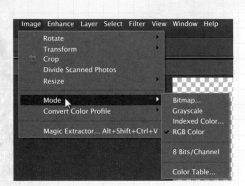

1 First save your file on your computer as a separate color file, by going to File > Save As.

2 Now check to see if your line-art is in Monochrome or Grayscale mode. If it is, you will not be able to apply color on your image as it will appear as a shade of gray. Go to Image > Mode and the menu will also reveal an RGB Color option. Select RGB Color and this will give you access to a palette of over 16 million colors.

4 Now create a new layer beneath the line-art layer, keeping the blend mode set at Normal. Use this as your base color layer.

5 Make another layer and place it beneath the color layer. This is your background layer. Fill the entire page with a light pastel color like light blue or light green. This is to help you spot any gaps in your coloring.

| ☐ Pattern | ▢ | Mode: Normal ▾ | Opacity: 100% ▾ | Tolerence 32 | ✓ Anti–alias | ✓ Contiguous | ✓ All Layers |

6 Select the Paint Bucket tool. Make sure the options on the Tool Options bar are set with Anti-alias off, and Contiguous and All Layers on. Set the Tolerance level to a small amount like 32, so that the neighboring areas are not filled with the color from the paint bucket.

7 On the base color layer, use the Paint Bucket tool to color in each part of the image. Start with the larger areas such as hair, skin, and clothes. Leave the accessories until later so that you can match these to the colors used on clothes and hair.

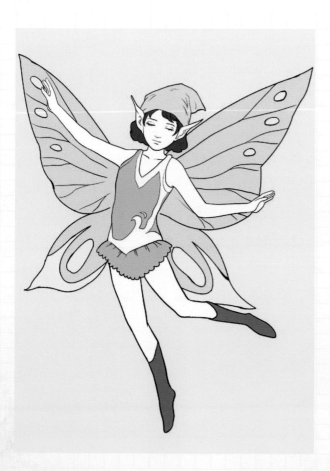

TIP

Rapid Color Swapping With The X and Alt Keys
Most often, while coloring, you will be using two colors at any given time. You can use the X key to rapidly switch between the foreground and background color and so you will have a "spare" color available at any time. You can also use the Alt key to quickly pick up colors from other parts of your image. This is useful in making sure your image is coordinated and will reduce the need for you to bring up the Color Picker window.

8 Select the Pencil tool and use this to begin adding detail. This is especially useful when filling in the small gaps with color and adding details such as eyebrows and strands of hair.

9 The Pencil tool also can be used for completing any parts of the drawing not fully defined by the line-art.

10 When you have finished adding all the base colors, you can begin to shade these colors to give your image depth.

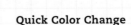

Quick Color Change
The advantage of working in Photoshop is that if you change your mind about the colors you have chosen, you can still change these even if you've already finished adding all the base colors. Uncheck the Contiguous box in the Tool Options bar, choose a different color, and use the Paint Bucket tool to fill in an area with the new color with a simple click of your mouse.

Using Contiguous to Speed Up Coloring

Sometimes, images can be quite complicated to color, especially if there are elaborate patterns on the clothes. To fill each of these patterns individually can be time consuming. The Contiguous setting in the Paint Bucket tool can make things easier.

Turning Contiguous off means you can fill the entire area very quickly and even though the color might flood into areas that do not need them, it might be quicker to remove the few overspills than have to painstakingly color each element of your image. If you use the Selection tool, you can control which areas are colored.

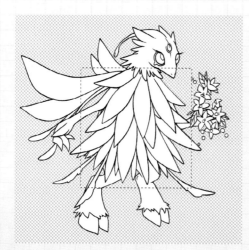

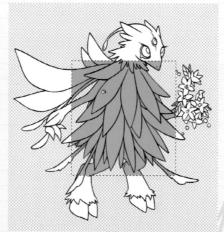

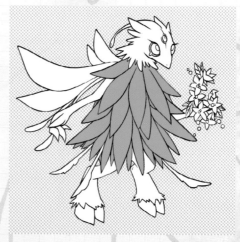

1 Roughly select the area you want to fill in with color. In this example, the Rectangular Selection tool has been used.

2 Select the Paint Bucket tool and with Contiguous switched off, fill in the color in your selected area.

3 Now turn Contiguous back on and fix the excess color. This method has avoided having to fill in every leaf element of the outfit on the fairy.

Shading

Shading is an important aspect of coloring as it is crucial when it comes to adding depth and accents to your image. How you shade the image can give the impression of light and shadow, and those extra highlights can make an image look extraordinary.

It is possible to shade your image using the Dodge, Burn, and Smudge tools discussed earlier in the book, but most artists prefer to create a separate shading layer and shade the image in with the use of additional colors.

Shading

The lightest part of your image should be areas that face a light source, with the darkest parts being those that face away, or are hidden from the light. An object is affected equally by light, unless the source is very weak, such as the flame from a flickering candle—so the same amount of light falls on the area facing towards your source.

The light source on this fairy is coming from the top right so any areas facing away from there have been shaded darker.

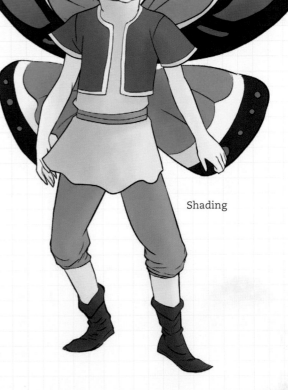

Shading

Original

This fairy has been colored in with simple block colors. When moving on to adding your shading, the most important thing to remember is how light falls on an object and how the shape of an object will affect this.

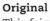

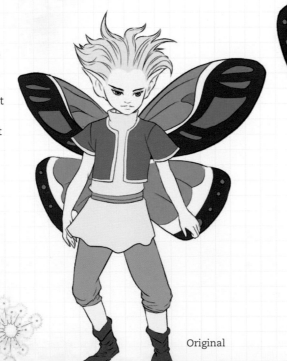

Original

Shadows

Shadows help to define the shape of your image and how "solid" it appears. Your picture becomes a lot more realistic when objects within a scene affect each other by casting shadows, such as the shadows cast by the individual folds on this fairy's clothing.

In the second image the fairy casts a shadow onto the floor. The shape of his body is defined by the shadow's shape—you can see the wings faintly. Also, the areas that are cast in shadow by other parts of the body are shaded darker to reflect this, such as the legs, also shown in the first image.

Shadows 1

Shadows 2

Highlights

Highlights are not a must, but they can add degrees of sharper lighting to shiny areas of your image (such as wing tips or somethimes clothing) as well as areas in the direct spotlight from your source. You can have soft highlights and strong highlights and they do not always have to follow the direction of the light source, implying there is other light nearby—this is called "backlighting" and gives more volume to an object.

Highlights

Applying Shading

As shown on the previous pages, shading adds realism to your artwork. Software like Photoshop allows you to emulate the look of traditional shading using soft brushes and, by using layers, helps to speed up the process!

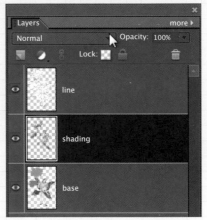

2 Now create a new layer for your shading and set the layer blend mode to Normal.

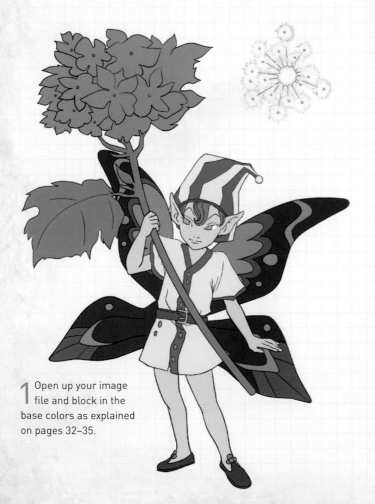

1 Open up your image file and block in the base colors as explained on pages 32–35.

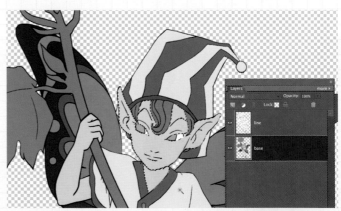

3 Go back to the base layer to select the areas you wish to shade using the Magic Wand tool. This lets you shade an area, such as the face of your fairy, without going over the lines into other parts of your image.

4 On your shading layer, using a paintbrush with a very soft tip, low opacity, and low flow, begin shading the image. Pick colors that are a few shades darker than the base layer that you are shading.

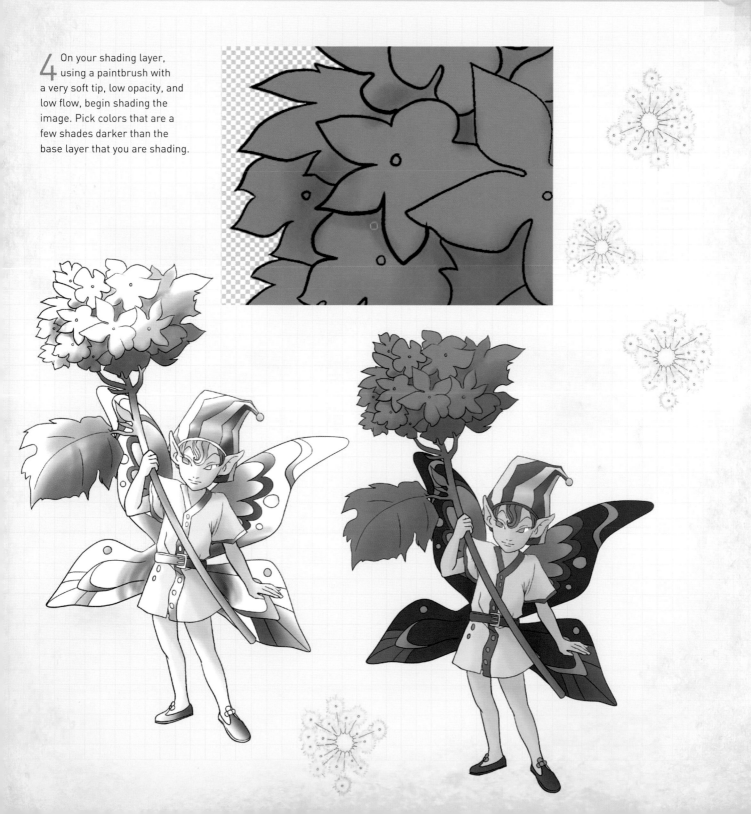

5 Now create another layer and name this the Shadow layer. Set the layer blend mode to Normal. Use an even smaller brush with low opacity and low flow to draw in the dark shadows. Pick colors that are quite a few shades darker than the colors used for shading. As before, use the base layer to pick the selection areas.

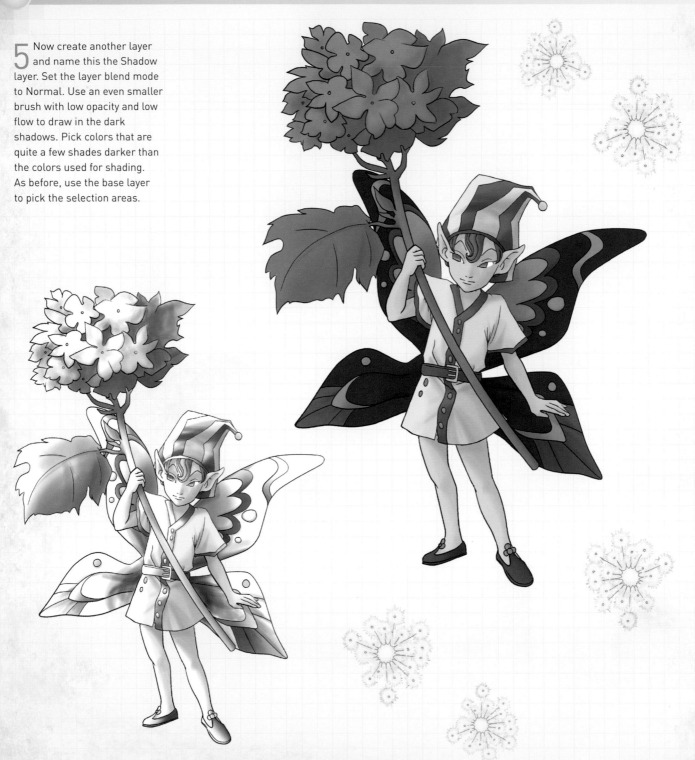

6 To add highlights, create a highlight layer with the blending mode set to normal and place this layer above the shadow layer. Keep using a low opacity and low flow soft brush, and use white paint to add highlights and accents to the parts of your image that are facing the light source. To add stronger highlights you can increase the opacity of your brush.

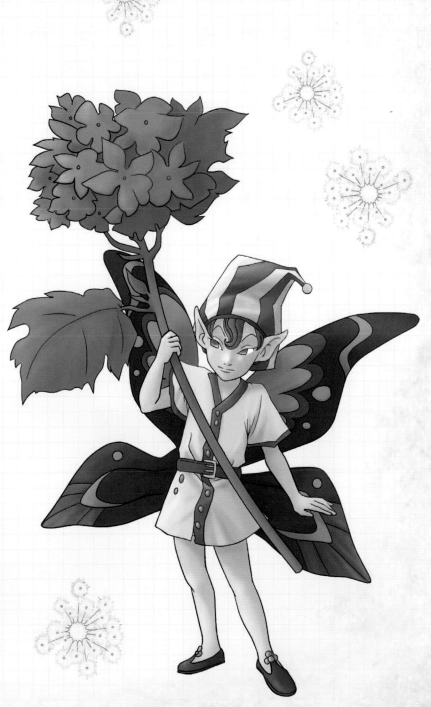

Fine-Tuning Your Colors

Digitally coloring your artwork allows you a lot of freedom to tweak your image at many stages throughout the coloring process. For example you can quickly change the color of your fairy's boots using the Paint Bucket tool, even after you have added all your other base colors.

Another way to tweak your fairy artwork is by adjusting the Hue and Saturation of your colors.

This can be done at any stage, once you have added all your base colors, or even once you have added all your shading and highlights as well.

The world of fairies is filled with rich colors and there are no set rules for how your artwork should look, so don't be afraid to experiment and let your imagination guide you.

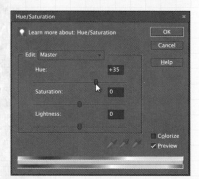

To fine-tune your colors go to Enhance > Adjust Color > Adjust Hue/Saturation in Elements (or Image > Adjustments and select Hue/Saturation in Photoshop). By dragging the sliders across you can increase or decrease the Hue, Saturation, and Lightness of your colors, creating many alternative looks.

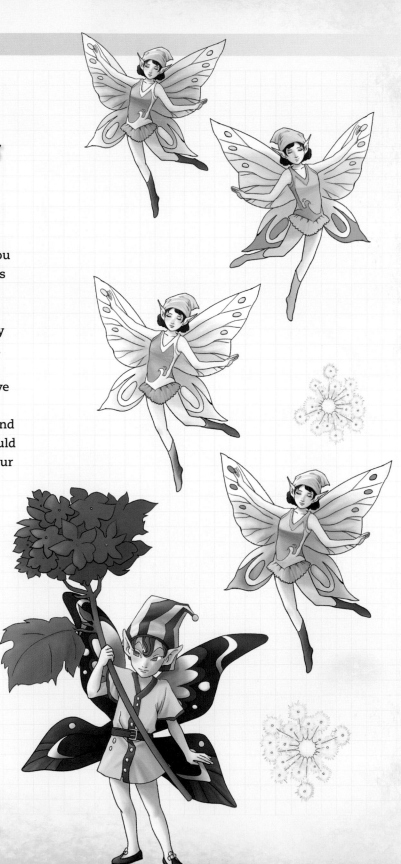

You can create many different fairies from just one image to go together in a fairy scene. If you want to change the mood of your scene, or your setting from day to night, you can easily adjust the colors to suit.

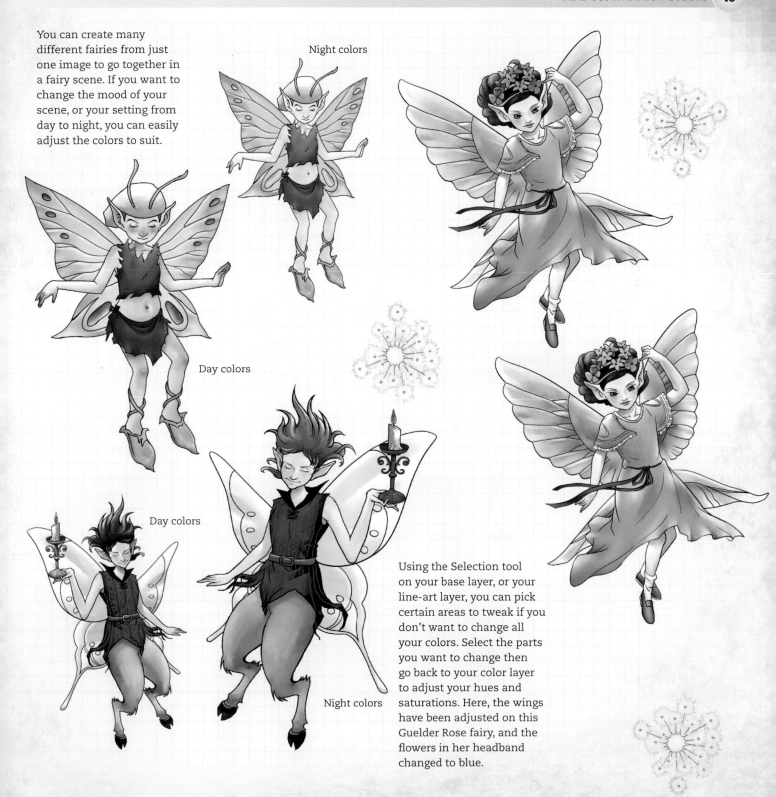

Night colors

Day colors

Day colors

Night colors

Using the Selection tool on your base layer, or your line-art layer, you can pick certain areas to tweak if you don't want to change all your colors. Select the parts you want to change then go back to your color layer to adjust your hues and saturations. Here, the wings have been adjusted on this Guelder Rose fairy, and the flowers in her headband changed to blue.

Fairies

This section is a gallery of just some of the many variations that can be made for each of the fairy sets. Alongside each fairy set is the layers bar, which lists all the elements you can put together to create the look of your fairy.

Sylph Fairies

BALLET DANCERS OF THE SKY

To get a feel for what a sylph fairy is cast your eye to the ballet in the skies on a calm day—wispy clouds and dainty shapes always changing. Sylphs are elemental spirits that represent air. They can be male or female, and are characteristically graceful. These flighty fairies are traditional characters that have been around in folklore since medieval times. They are present in Shakespeare's *A Midsummer Night's Dream* as well as in the ballet *Les Sylphides*.

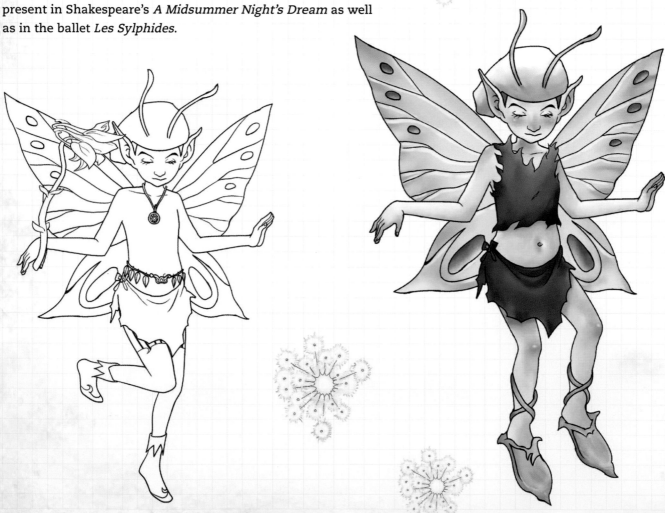

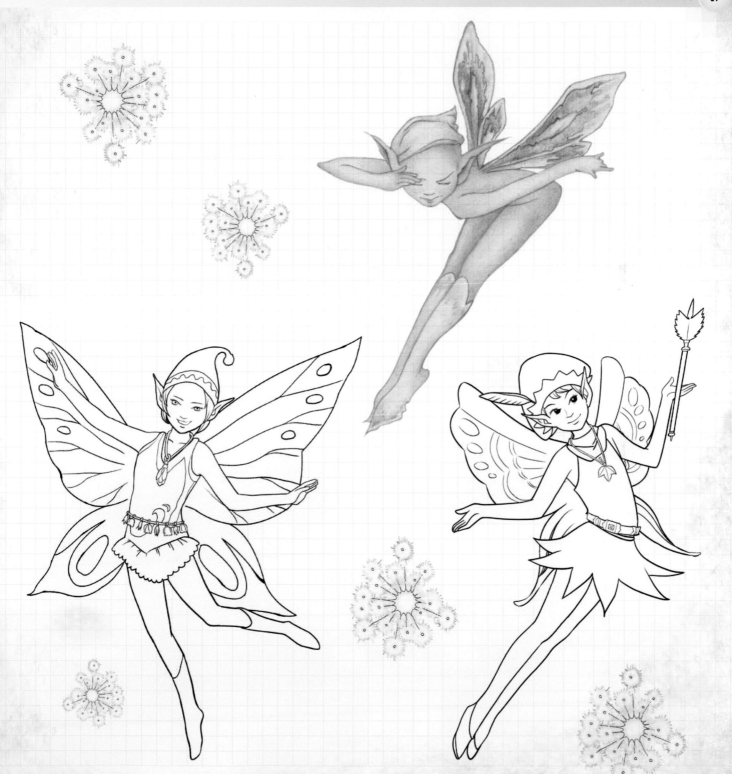

Sylph 1

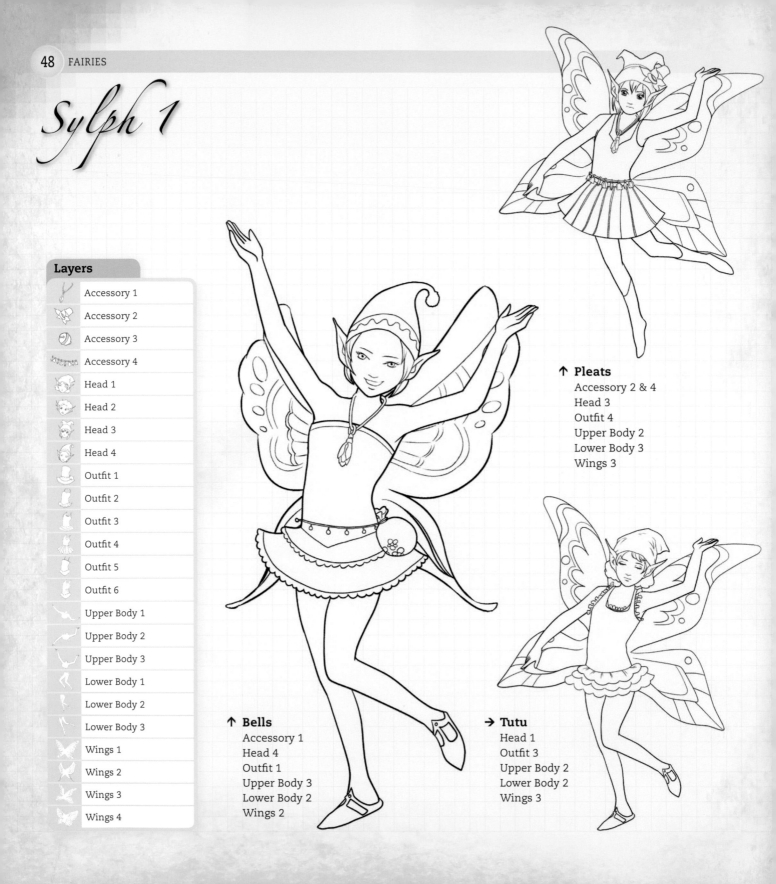

Layers

- Accessory 1
- Accessory 2
- Accessory 3
- Accessory 4
- Head 1
- Head 2
- Head 3
- Head 4
- Outfit 1
- Outfit 2
- Outfit 3
- Outfit 4
- Outfit 5
- Outfit 6
- Upper Body 1
- Upper Body 2
- Upper Body 3
- Lower Body 1
- Lower Body 2
- Lower Body 3
- Wings 1
- Wings 2
- Wings 3
- Wings 4

↑ **Pleats**
Accessory 2 & 4
Head 3
Outfit 4
Upper Body 2
Lower Body 3
Wings 3

↑ **Bells**
Accessory 1
Head 4
Outfit 1
Upper Body 3
Lower Body 2
Wings 2

→ **Tutu**
Head 1
Outfit 3
Upper Body 2
Lower Body 2
Wings 3

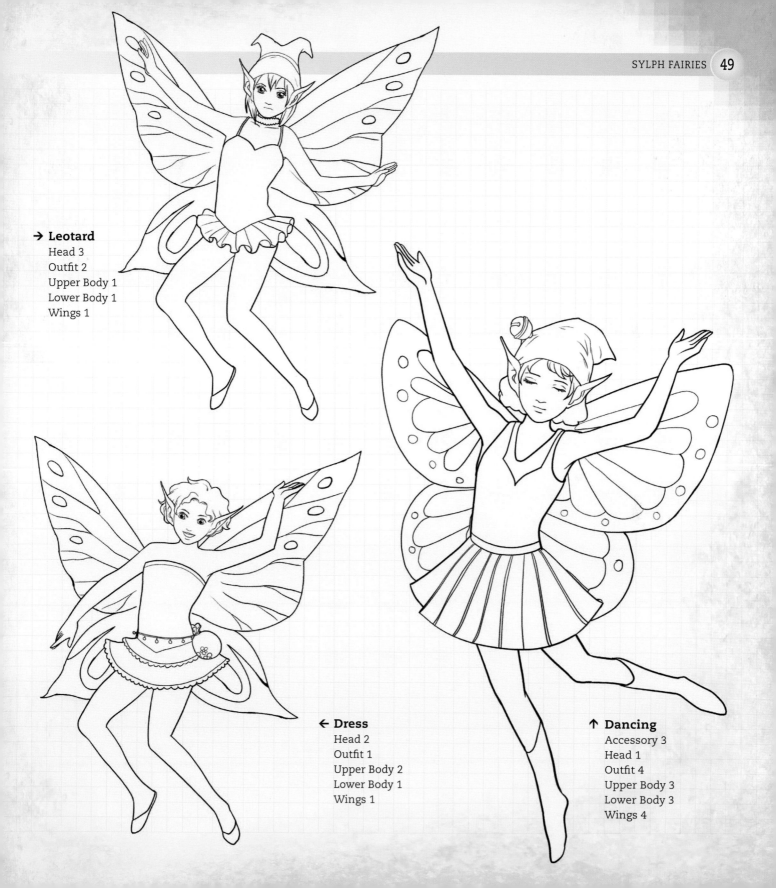

→ Leotard
Head 3
Outfit 2
Upper Body 1
Lower Body 1
Wings 1

← Dress
Head 2
Outfit 1
Upper Body 2
Lower Body 1
Wings 1

↑ Dancing
Accessory 3
Head 1
Outfit 4
Upper Body 3
Lower Body 3
Wings 4

Sylph 2

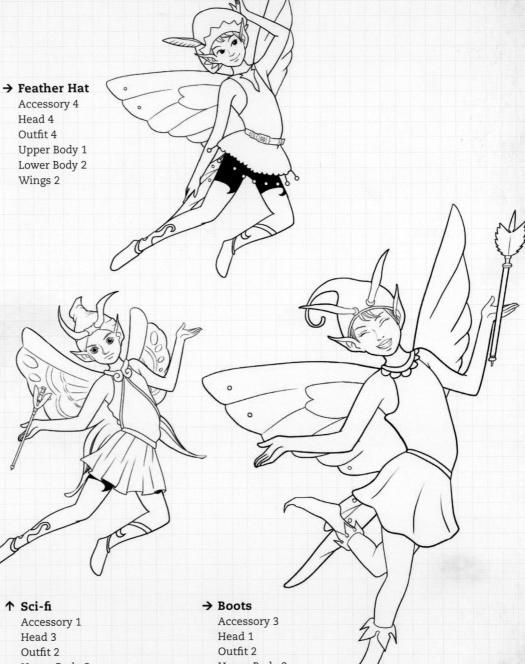

→ Feather Hat
Accessory 4
Head 4
Outfit 4
Upper Body 1
Lower Body 2
Wings 2

Layers

- Accessory 1
- Accessory 2
- Accessory 3
- Accessory 4
- Head 1
- Head 2
- Head 3
- Head 4
- Outfit 1
- Outfit 2
- Outfit 3
- Outfit 4
- Outfit 5
- Outfit 6
- Upper Body 1
- Upper Body 2
- Upper Body 3
- Lower Body 1
- Lower Body 2
- Lower Body 3
- Wings 1
- Wings 2
- Wings 3
- Wings 4

↑ Sci-fi
Accessory 1
Head 3
Outfit 2
Upper Body 3
Lower Body 2
Wings 3

→ Boots
Accessory 3
Head 1
Outfit 2
Upper Body 3
Lower Body 1
Wings 2

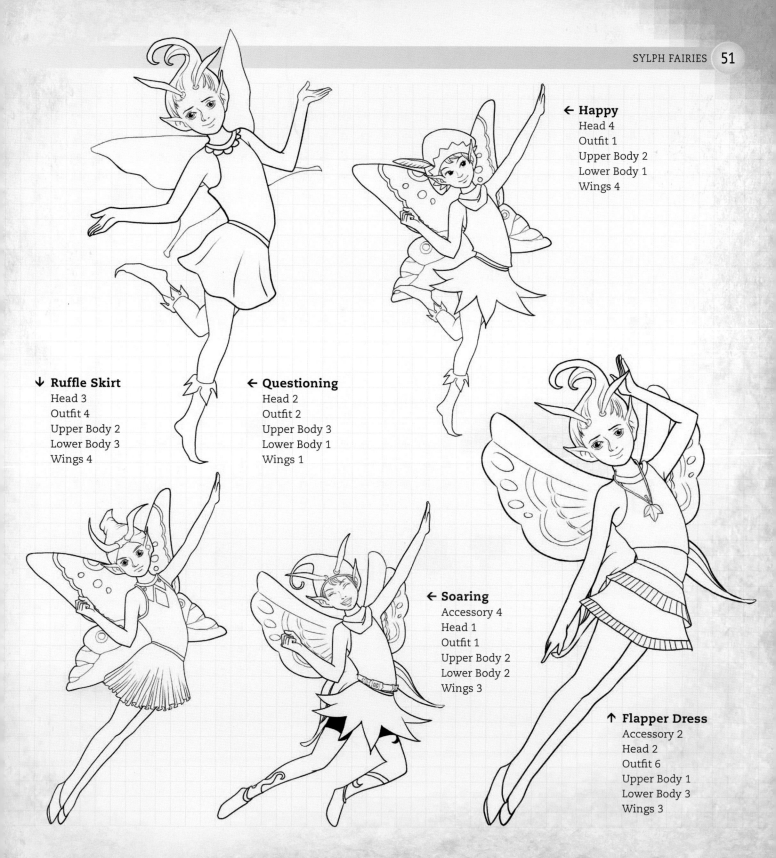

← Happy
Head 4
Outfit 1
Upper Body 2
Lower Body 1
Wings 4

↓ Ruffle Skirt
Head 3
Outfit 4
Upper Body 2
Lower Body 3
Wings 4

← Questioning
Head 2
Outfit 2
Upper Body 3
Lower Body 1
Wings 1

← Soaring
Accessory 4
Head 1
Outfit 1
Upper Body 2
Lower Body 2
Wings 3

↑ Flapper Dress
Accessory 2
Head 2
Outfit 6
Upper Body 1
Lower Body 3
Wings 3

Sylph 3

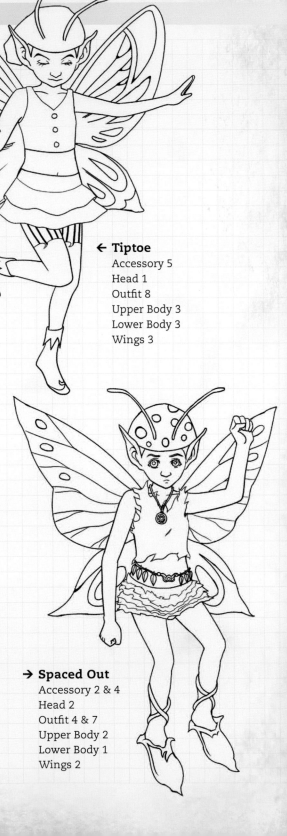

Layers

- Accessory 1
- Accessory 2
- Accessory 3
- Accessory 4
- Accessory 5
- Head 1
- Head 2
- Head 3
- Head 4
- Outfit 1
- Outfit 2
- Outfit 3
- Outfit 4
- Outfit 5
- Outfit 6
- Outfit 7
- Outfit 8
- Upper Body 1
- Upper Body 2
- Upper Body 3
- Lower Body 1
- Lower Body 2
- Lower Body 3
- Wings 1
- Wings 2
- Wings 3
- Wings 4

← **Tiptoe**
Accessory 5
Head 1
Outfit 8
Upper Body 3
Lower Body 3
Wings 3

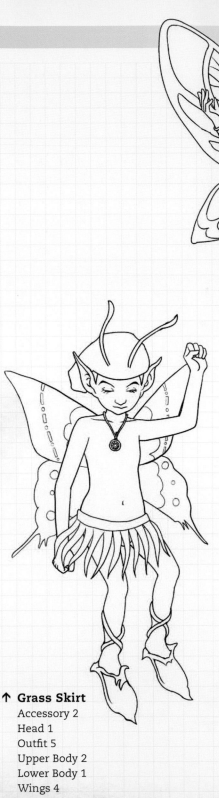

↑ **Grass Skirt**
Accessory 2
Head 1
Outfit 5
Upper Body 2
Lower Body 1
Wings 4

→ **Spaced Out**
Accessory 2 & 4
Head 2
Outfit 4 & 7
Upper Body 2
Lower Body 1
Wings 2

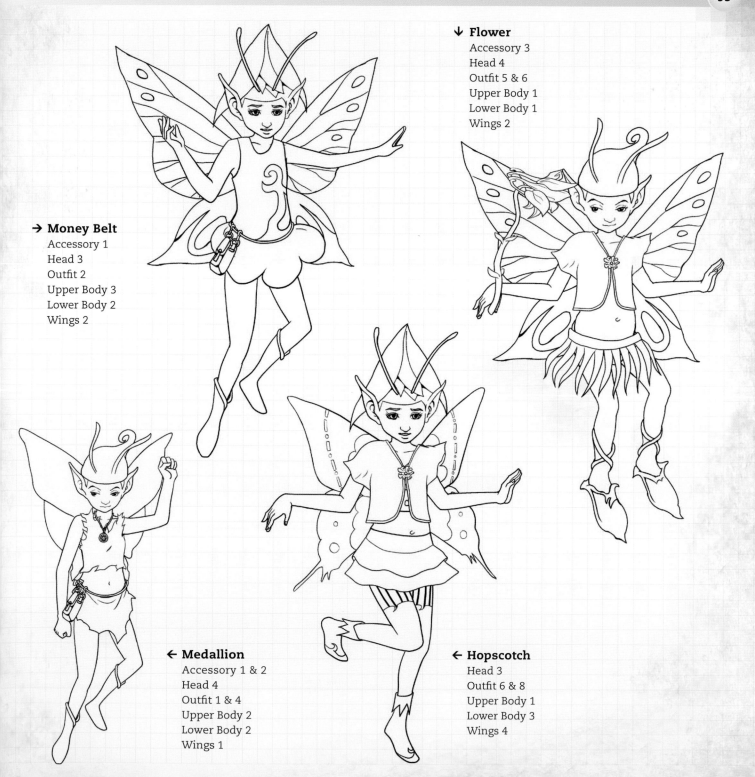

↓ Flower
Accessory 3
Head 4
Outfit 5 & 6
Upper Body 1
Lower Body 1
Wings 2

→ Money Belt
Accessory 1
Head 3
Outfit 2
Upper Body 3
Lower Body 2
Wings 2

← Medallion
Accessory 1 & 2
Head 4
Outfit 1 & 4
Upper Body 2
Lower Body 2
Wings 1

← Hopscotch
Head 3
Outfit 6 & 8
Upper Body 1
Lower Body 3
Wings 4

Flower Fairies

FAIRIES AT THE BOTTOM OF MY GARDEN

The term "Flower Fairies" was first coined by Lydia Maria Child, an activist, journalist, and novelist, who in 1850 wrote the book *Rose Marian and the Flower Fairies*. Around the same time, flowers were a popular subject in art with the Victorians in Britain. Illustrator Kate Greenaway published a book called *The Language of Flowers*, which described the romantic meanings of different flower varieties and was illustrated with drawings of small children and flowers. This inspired other artists to draw ethereal children dressed in botanically correct flowers with insect or butterfly wings, and so the flower fairy as we recognize them today was born. Flower fairies epitomize all that is beautiful about nature and the joy of innocence.

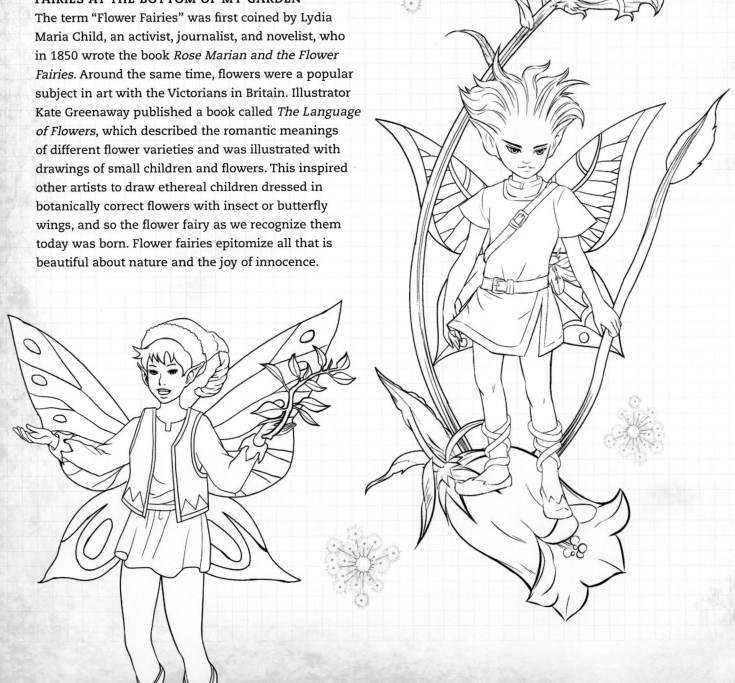

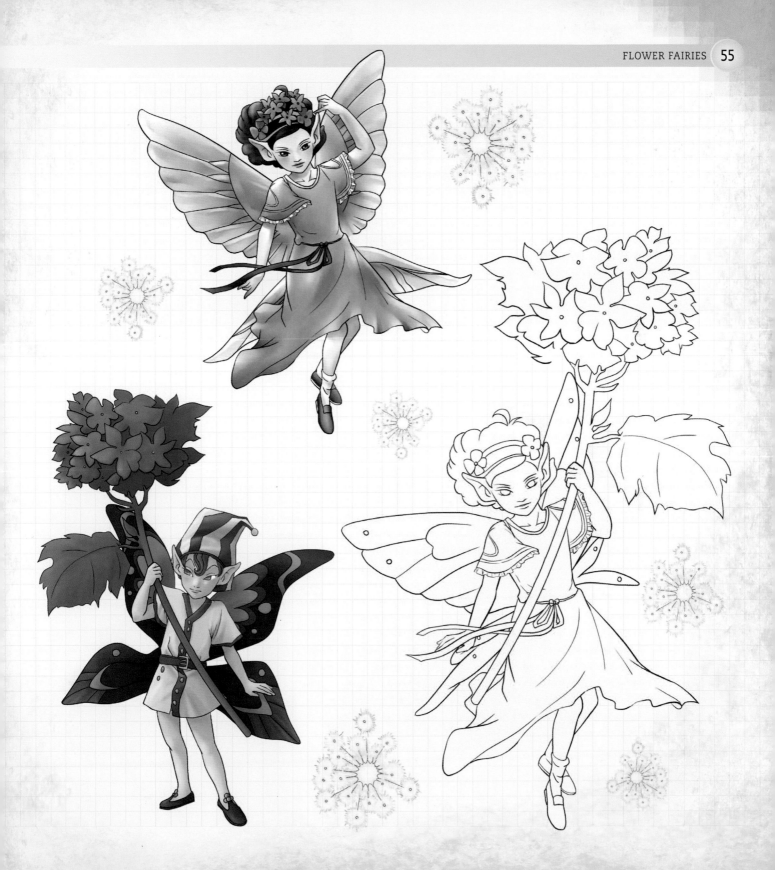

Canterbury Bell

Layers

- Head 1
- Head 2
- Head 3
- Head 4
- Outfit 1
- Outfit 2
- Outfit 3
- Outfit 4
- Outfit 5
- Outfit 6
- Upper Body 1
- Upper Body 2
- Upper Body 3
- Lower Body 1
- Lower Body 2
- Lower Body 3
- Accessory 1
- Accessory 2
- Accessory 3
- Accessory 4
- Accessory 5
- Wings 1
- Wings 2
- Wings 3
- Wings 4

← **Petal Skirt**
Accessory 3, 4 & 5
Head 1
Outfit 4
Upper Body 2
Lower Body 3
Wings 2

← **Flower Prince**
Accessory 2 & 3
Head 1
Outfit 3
Upper Body 1
Lower Body 1
Wings 3

↓ **Explorer**
Accessory 2, 5 & 4
Head 2
Outfit 5
Upper Body 3
Lower Body 2
Wings 4

← **Flower Bulb Dress**
Accessory 2, 4 & 5
Head 2
Outfit 1
Upper Body 1
Lower Body 1
Wings 1

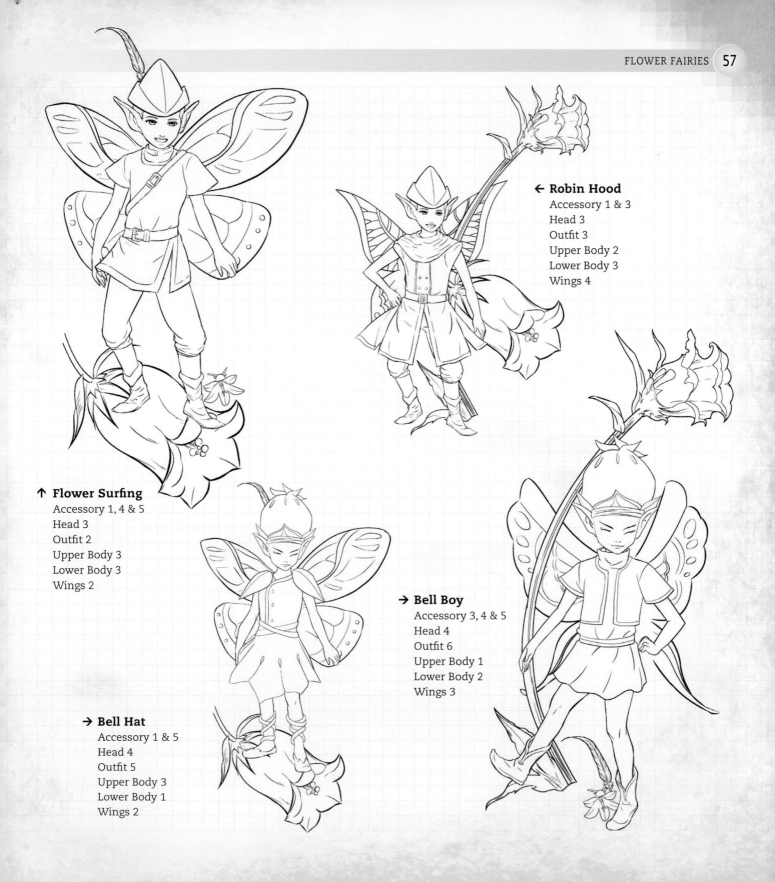

← Robin Hood
Accessory 1 & 3
Head 3
Outfit 3
Upper Body 2
Lower Body 3
Wings 4

↑ Flower Surfing
Accessory 1, 4 & 5
Head 3
Outfit 2
Upper Body 3
Lower Body 3
Wings 2

→ Bell Boy
Accessory 3, 4 & 5
Head 4
Outfit 6
Upper Body 1
Lower Body 2
Wings 3

→ Bell Hat
Accessory 1 & 5
Head 4
Outfit 5
Upper Body 3
Lower Body 1
Wings 2

Guelder Rose

Layers

	Accessory 1
	Accessory 2
	Accessory 3
	Accessory 4
	Accessory 5
	Accessory 6
	Accessory 7
	Head 1
	Head 2
	Head 3
	Head 4
	Outfit 1
	Outfit 2
	Outfit 3
	Outfit 4
	Outfit 5
	Outfit 6
	Upper Body 1
	Upper Body 2
	Upper Body 3
	Lower Body 1
	Lower Body 2
	Lower Body 3
	Wings 1
	Wings 2
	Wings 3
	Wings 4

↑ **Lilly**
Accessory 4
Head 1
Outfit 5
Upper Body 3
Lower Body 2
Wings 1

↑ **Flower Patch**
Accessory 2, 3, 4 & 6
Head 4
Outfit 6
Upper Body 1
Lower Body 2
Wings 1

→ **Daisy Chain**
Accessory 3
Head 1
Outfit 6
Upper Body 2
Lower Body 3
Wings 4

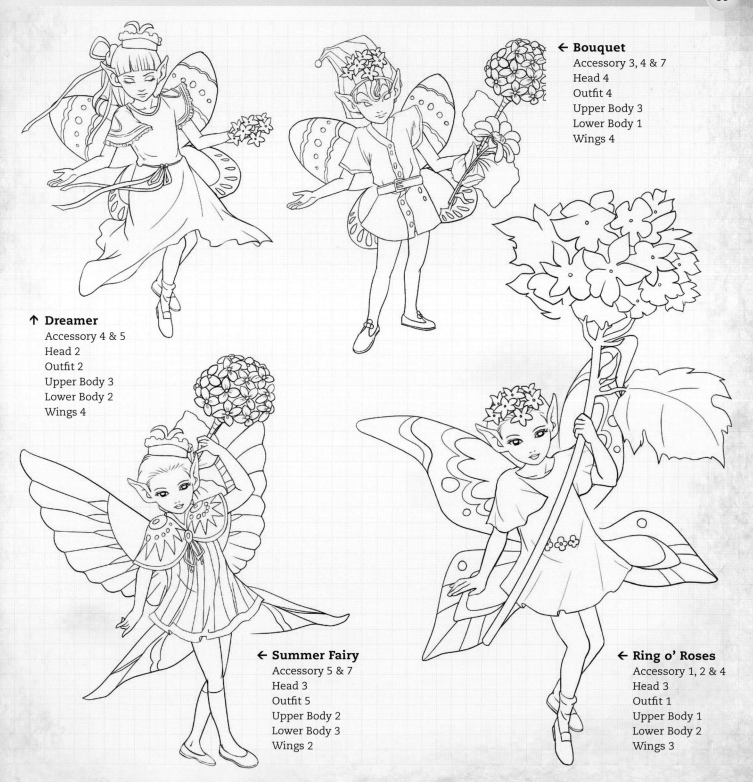

← Bouquet
Accessory 3, 4 & 7
Head 4
Outfit 4
Upper Body 3
Lower Body 1
Wings 4

↑ Dreamer
Accessory 4 & 5
Head 2
Outfit 2
Upper Body 3
Lower Body 2
Wings 4

← Summer Fairy
Accessory 5 & 7
Head 3
Outfit 5
Upper Body 2
Lower Body 3
Wings 2

← Ring o' Roses
Accessory 1, 2 & 4
Head 3
Outfit 1
Upper Body 1
Lower Body 2
Wings 3

Poppy

Layers

- Accessory 1
- Accessory 2
- Accessory 3
- Accessory 4
- Head 1
- Head 2
- Head 3
- Head 4
- Outfit 1
- Outfit 2
- Outfit 3
- Outfit 4
- Outfit 5
- Outfit 6
- Upper Body 1
- Upper Body 2
- Upper Body 3
- Lower Body 1
- Lower Body 2
- Lower Body 3
- Wings 1
- Wings 2
- Wings 3
- Wings 4

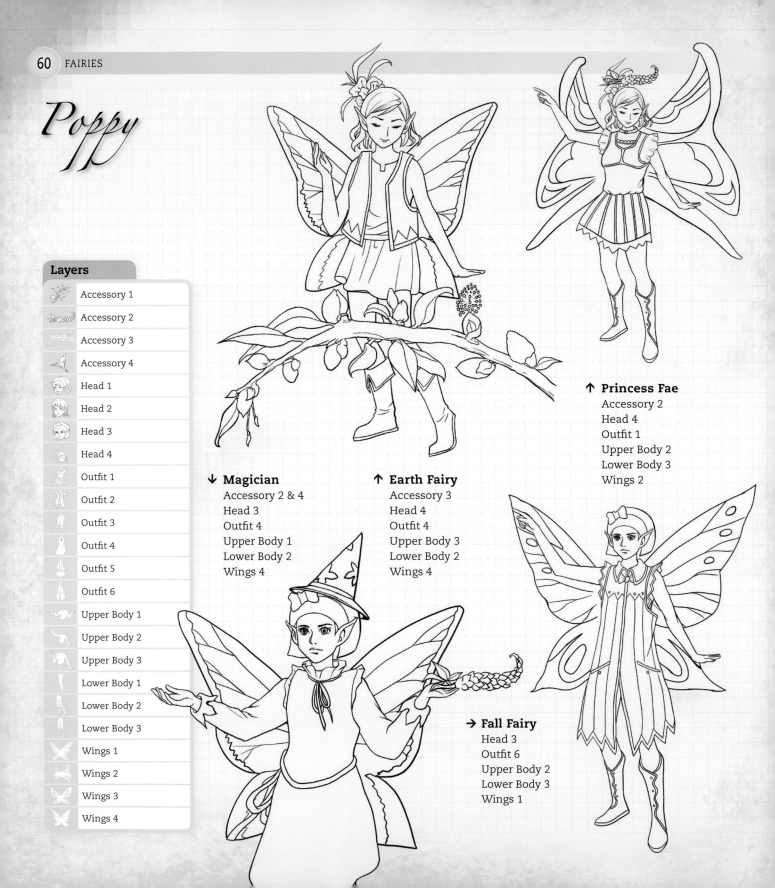

↑ **Princess Fae**
Accessory 2
Head 4
Outfit 1
Upper Body 2
Lower Body 3
Wings 2

↓ **Magician**
Accessory 2 & 4
Head 3
Outfit 4
Upper Body 1
Lower Body 2
Wings 4

↑ **Earth Fairy**
Accessory 3
Head 4
Outfit 4
Upper Body 3
Lower Body 2
Wings 4

→ **Fall Fairy**
Head 3
Outfit 6
Upper Body 2
Lower Body 3
Wings 1

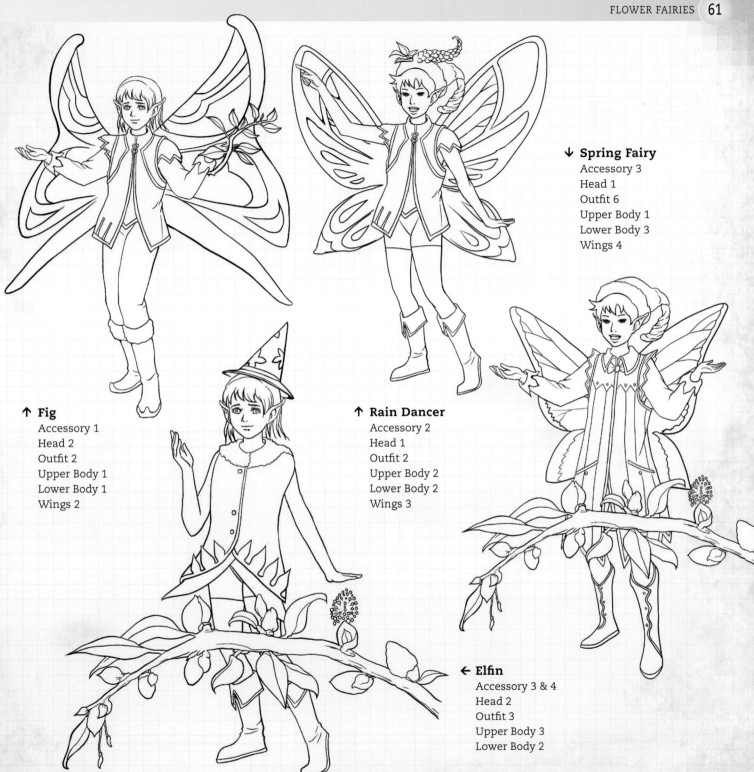

↓ Spring Fairy
Accessory 3
Head 1
Outfit 6
Upper Body 1
Lower Body 3
Wings 4

↑ Fig
Accessory 1
Head 2
Outfit 2
Upper Body 1
Lower Body 1
Wings 2

↑ Rain Dancer
Accessory 2
Head 1
Outfit 2
Upper Body 2
Lower Body 2
Wings 3

← Elfin
Accessory 3 & 4
Head 2
Outfit 3
Upper Body 3
Lower Body 2

Contemporary Fairies

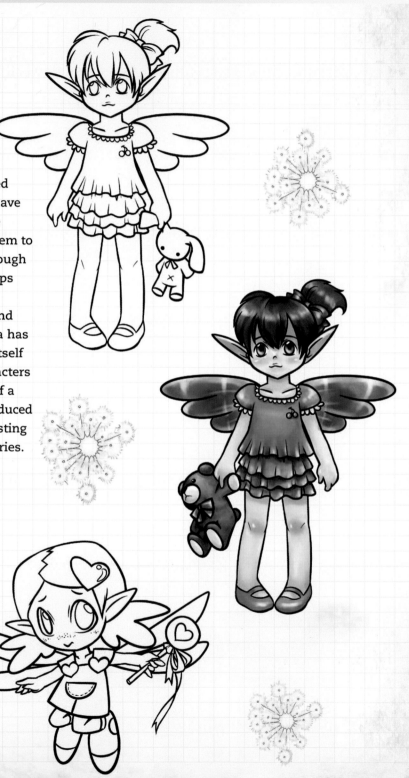

FAIRIES OF THE FUTURE

Folklore's traditional image of the fairy has changed over time within modern popular culture. Fairies have been revived through fresh interpretations and the popularity of fantasy films have helped to bring them to a wider audience. Generally we identify fairies through the addition of wings. However, as the Internet helps people to share their different artistic styles and concepts in just a few keystrokes, the influences and styles of fairy art have broadened. Japanese manga has become particularly popular, and this style lends itself well to fairy art. Manga's typically wide-eyed characters are able to radiate the innocence and cheekiness of a more traditional fairy like Tinkerbell, but have introduced traits such as colorful clothing, hairstyles of contrasting color or many colors, jewelry, and modern accessories.

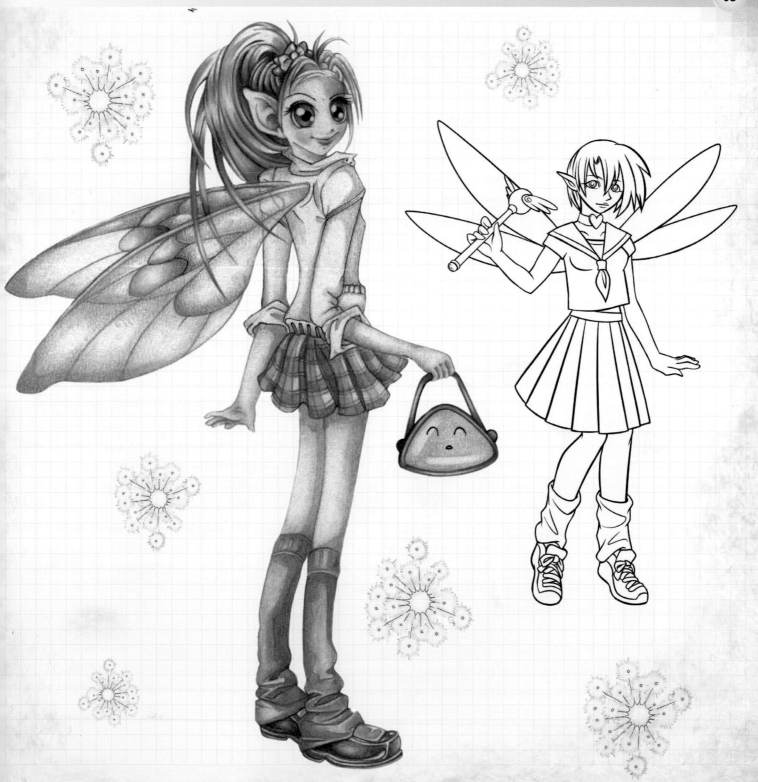

Chibi

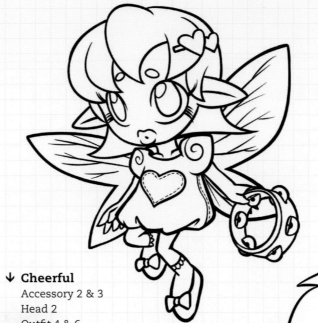

← **Tambourine Girl**
Accessory 2 & 4
Head 4
Outfit 1
Upper Body 2
Lower Body 2
Wings 1

↓ **Cheerful**
Accessory 2 & 3
Head 2
Outfit 4 & 6
Upper Body 1
Lower Body 2
Wings 3

↑ **Safety Pins**
Accessory 4
Head 2
Outfit 3
Upper Body 2
Lower Body 2
Wings 3

Layers

	Accessory 1
	Accessory 2
	Accessory 3
	Accessory 4
	Outfit 1
	Outfit 2
	Outfit 3
	Outfit 4
	Outfit 5
	Outfit 6
	Head 1
	Head 2
	Head 3
	Head 4
	Upper Body 1
	Upper Body 2
	Upper Body 3
	Lower Body 1
	Lower Body 2
	Lower Body 3
	Lower Body 4
	Wings 1
	Wings 2
	Wings 3
	Wings 4

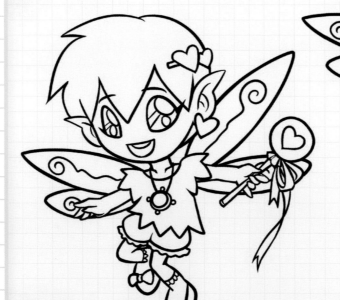

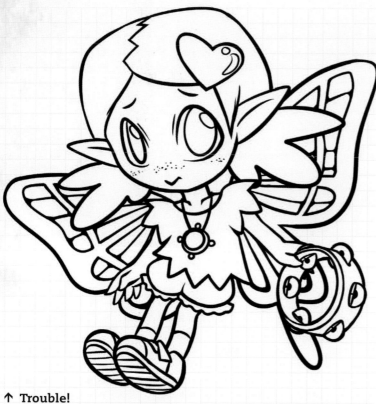

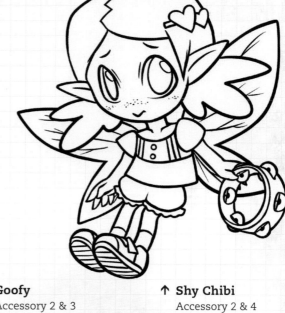

↓ Goofy
Accessory 2 & 3
Head 3
Outfit 2
Upper Body 1
Lower Body 2
Wings 3

↑ Shy Chibi
Accessory 2 & 4
Head 1
Outfit 4 & 5
Upper Body 2
Lower Body 3
Wings 1

↑ Trouble!
Accessory 1 & 4
Head 1
Outfit 4 & 6
Upper Body 2
Lower Body 3
Wings 2

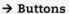

→ Buttons
Accessory 3
Head 3
Outfit 3
Upper Body 3
Lower Body 4
Wings 1

Child

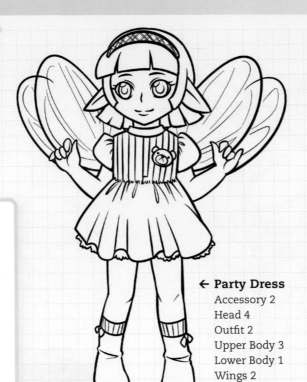

Layers

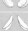	Accessory 1
	Accessory 2
	Accessory 3
	Accessory 4
	Outfit 1
	Outfit 2
	Outfit 3
	Outfit 4
	Outfit 5
	Outfit 6
	Head 1
	Head 2
	Head 3
	Head 4
	Upper Body 1
	Upper Body 2
	Upper Body 3
	Lower Body 1
	Lower Body 2
	Lower Body 3
	Lower Body 4
	Wings 1
	Wings 2
	Wings 3
	Wings 4

← **Party Dress**
Accessory 2
Head 4
Outfit 2
Upper Body 3
Lower Body 1
Wings 2

↑ **Cherry**
Accessory 3
Head 4
Outfit 4 & 5
Upper Body 1
Lower Body 1
Wings 3

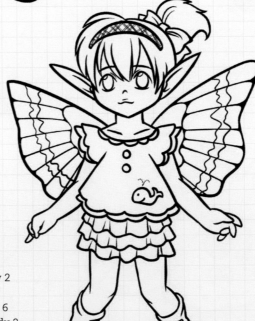

→ **Marina**
Accessory 2
Head 1
Outfit 4 & 6
Upper Body 2
Lower Body 3
Wings 1

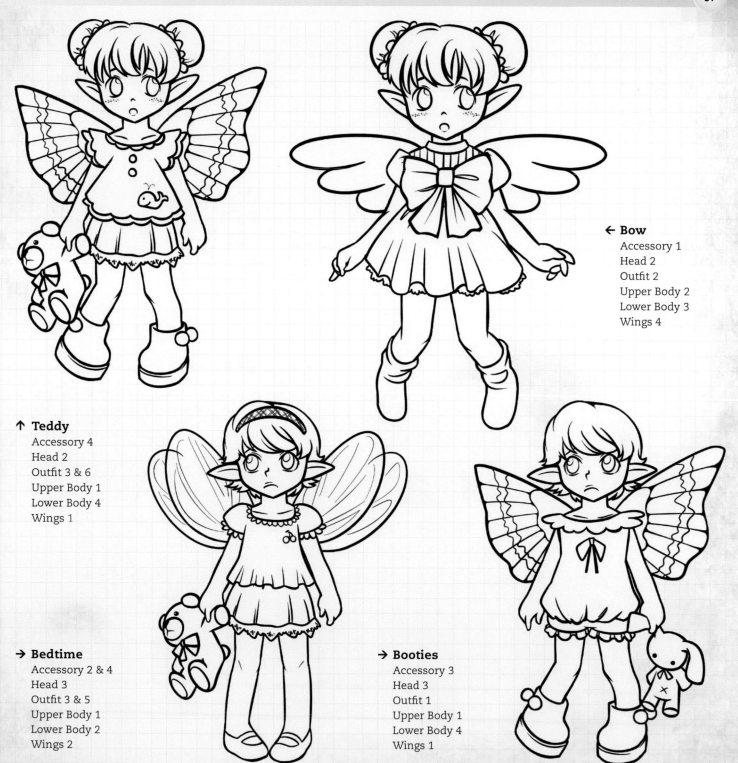

← **Bow**
Accessory 1
Head 2
Outfit 2
Upper Body 2
Lower Body 3
Wings 4

↑ **Teddy**
Accessory 4
Head 2
Outfit 3 & 6
Upper Body 1
Lower Body 4
Wings 1

→ **Bedtime**
Accessory 2 & 4
Head 3
Outfit 3 & 5
Upper Body 1
Lower Body 2
Wings 2

→ **Booties**
Accessory 3
Head 3
Outfit 1
Upper Body 1
Lower Body 4
Wings 1

Manga Female

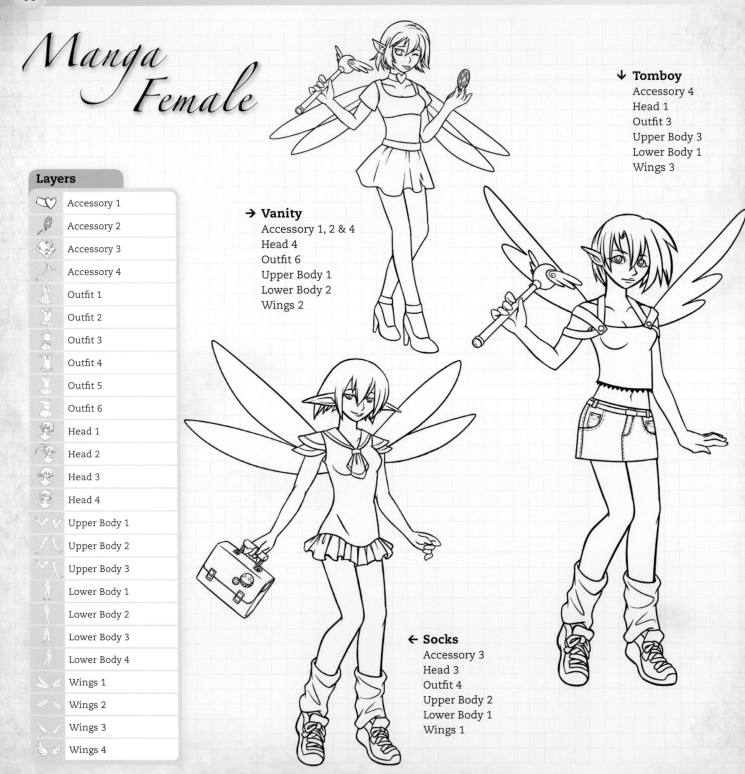

Layers

- Accessory 1
- Accessory 2
- Accessory 3
- Accessory 4
- Outfit 1
- Outfit 2
- Outfit 3
- Outfit 4
- Outfit 5
- Outfit 6
- Head 1
- Head 2
- Head 3
- Head 4
- Upper Body 1
- Upper Body 2
- Upper Body 3
- Lower Body 1
- Lower Body 2
- Lower Body 3
- Lower Body 4
- Wings 1
- Wings 2
- Wings 3
- Wings 4

↓ Tomboy
Accessory 4
Head 1
Outfit 3
Upper Body 3
Lower Body 1
Wings 3

→ Vanity
Accessory 1, 2 & 4
Head 4
Outfit 6
Upper Body 1
Lower Body 2
Wings 2

← Socks
Accessory 3
Head 3
Outfit 4
Upper Body 2
Lower Body 1
Wings 1

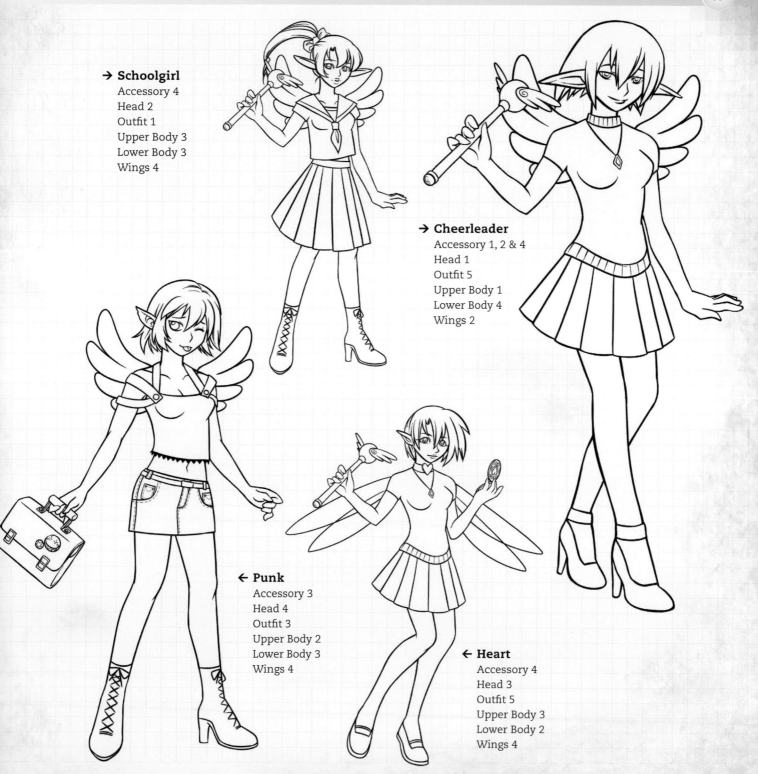

→ Schoolgirl
Accessory 4
Head 2
Outfit 1
Upper Body 3
Lower Body 3
Wings 4

→ Cheerleader
Accessory 1, 2 & 4
Head 1
Outfit 5
Upper Body 1
Lower Body 4
Wings 2

← Punk
Accessory 3
Head 4
Outfit 3
Upper Body 2
Lower Body 3
Wings 4

← Heart
Accessory 4
Head 3
Outfit 5
Upper Body 3
Lower Body 2
Wings 4

Gothic Fairies

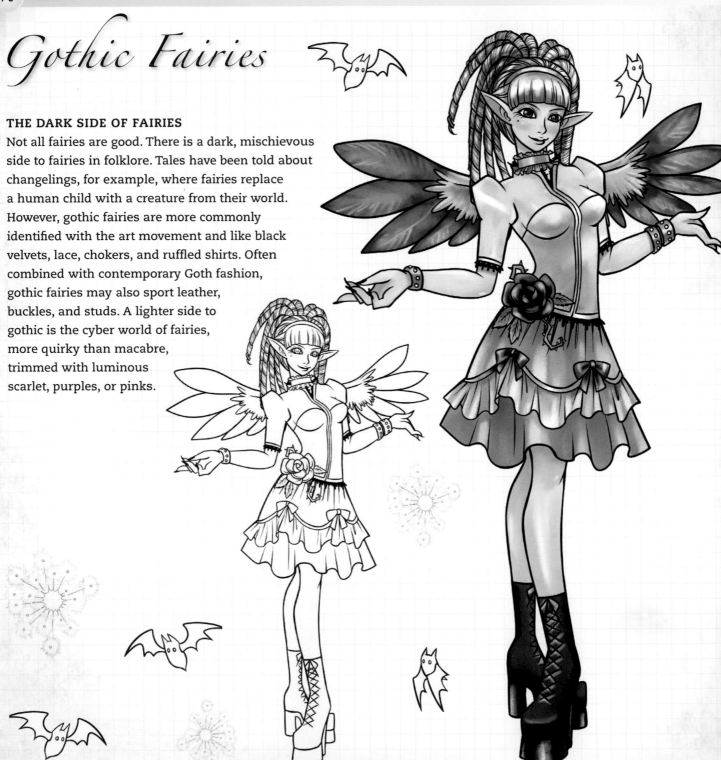

THE DARK SIDE OF FAIRIES

Not all fairies are good. There is a dark, mischievous side to fairies in folklore. Tales have been told about changelings, for example, where fairies replace a human child with a creature from their world. However, gothic fairies are more commonly identified with the art movement and like black velvets, lace, chokers, and ruffled shirts. Often combined with contemporary Goth fashion, gothic fairies may also sport leather, buckles, and studs. A lighter side to gothic is the cyber world of fairies, more quirky than macabre, trimmed with luminous scarlet, purples, or pinks.

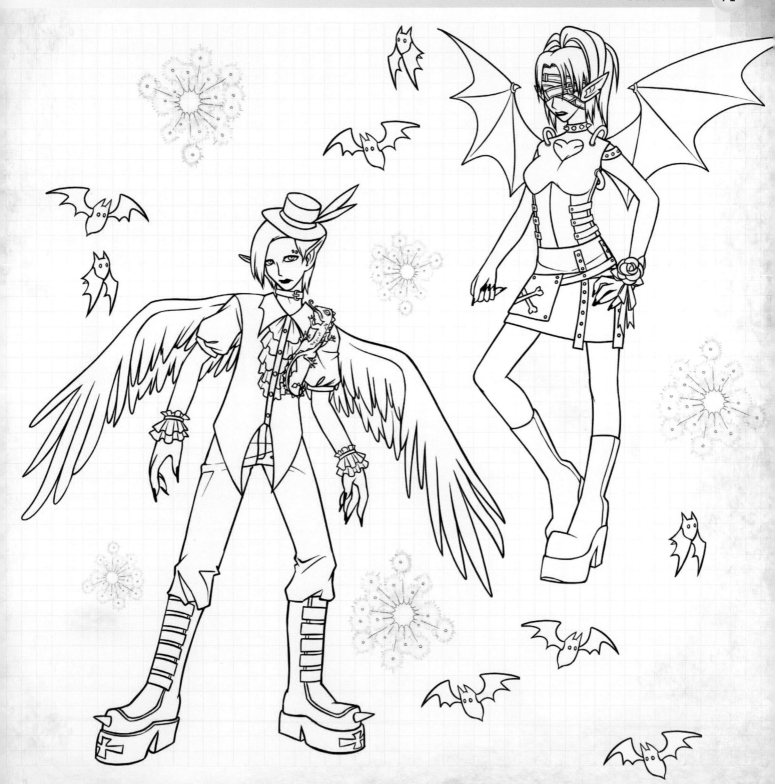

Gothic 1

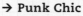

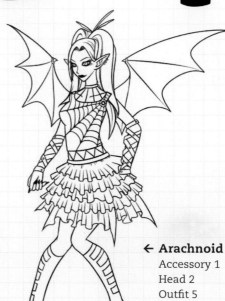

→ Punk Chic
Accessory 2
Head 4
Outfit 6
Upper Body 3
Lower Body 4
Wings 4

← Heavy Metal
Accessory 1 & 4
Head 4
Outfit 1
Upper Body 2
Lower Body 1
Wings 2

Layers

	Accessory 1
	Accessory 2
	Accessory 3
	Accessory 4
	Outfit 1
	Outfit 2
	Outfit 3
	Outfit 4
	Outfit 5
	Outfit 6
	Head 1
	Head 2
	Head 3
	Head 4
	Upper Body 1
	Upper Body 2
	Upper Body 3
	Lower Body 1
	Lower Body 2
	Lower Body 3
	Lower Body 4
	Wings 1
	Wings 2
	Wings 3
	Wings 4

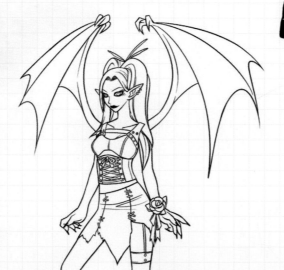

← Glam Rock
Accessory 3
Head 2
Outfit 2
Upper Body 3
Lower Body 4
Wings 3

← Arachnoid
Accessory 1
Head 2
Outfit 5
Upper Body 2
Lower Body 3
Wings 1

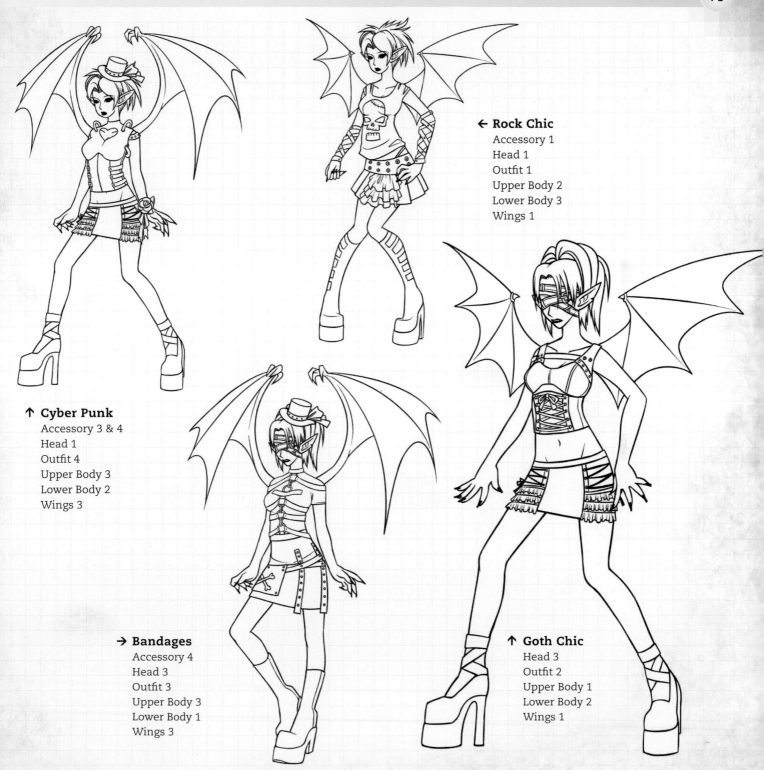

↑ Cyber Punk
Accessory 3 & 4
Head 1
Outfit 4
Upper Body 3
Lower Body 2
Wings 3

← Rock Chic
Accessory 1
Head 1
Outfit 1
Upper Body 2
Lower Body 3
Wings 1

→ Bandages
Accessory 4
Head 3
Outfit 3
Upper Body 3
Lower Body 1
Wings 3

↑ Goth Chic
Head 3
Outfit 2
Upper Body 1
Lower Body 2
Wings 1

Gothic 2

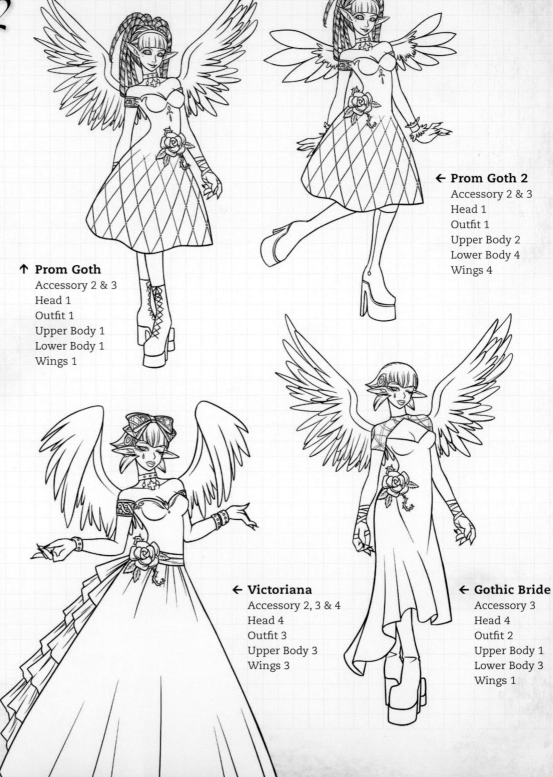

Layers

	Accessory 1
	Accessory 2
	Accessory 3
	Accessory 4
	Outfit 1
	Outfit 2
	Outfit 3
	Outfit 4
	Outfit 5
	Outfit 6
	Head 1
	Head 2
	Head 3
	Head 4
	Upper Body 1
	Upper Body 2
	Upper Body 3
	Lower Body 1
	Lower Body 2
	Lower Body 3
	Lower Body 4
	Wings 1
	Wings 2
	Wings 3
	Wings 4

↑ Prom Goth
Accessory 2 & 3
Head 1
Outfit 1
Upper Body 1
Lower Body 1
Wings 1

← Prom Goth 2
Accessory 2 & 3
Head 1
Outfit 1
Upper Body 2
Lower Body 4
Wings 4

← Victoriana
Accessory 2, 3 & 4
Head 4
Outfit 3
Upper Body 3
Wings 3

← Gothic Bride
Accessory 3
Head 4
Outfit 2
Upper Body 1
Lower Body 3
Wings 1

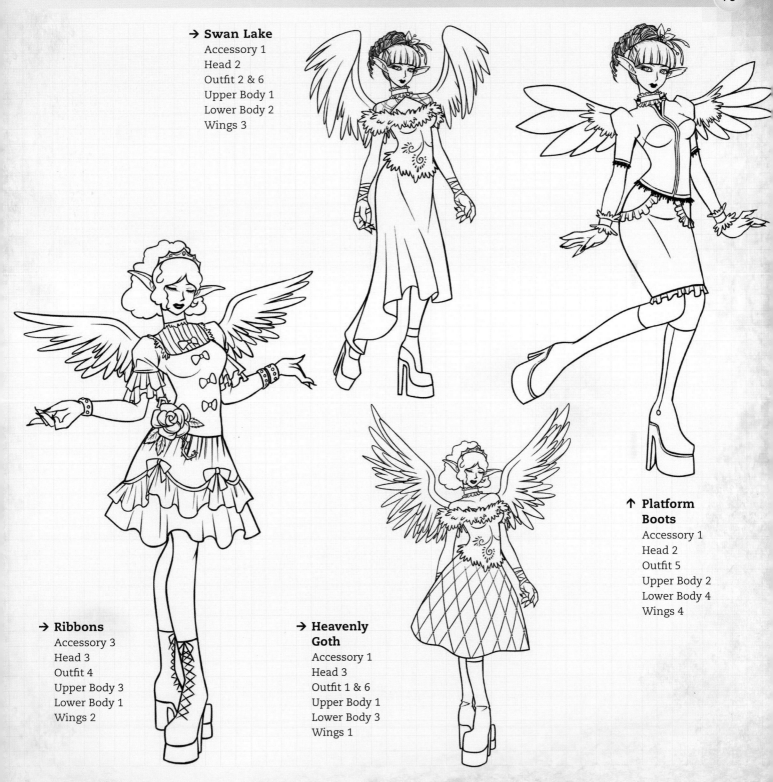

→ **Swan Lake**
Accessory 1
Head 2
Outfit 2 & 6
Upper Body 1
Lower Body 2
Wings 3

→ **Ribbons**
Accessory 3
Head 3
Outfit 4
Upper Body 3
Lower Body 1
Wings 2

→ **Heavenly Goth**
Accessory 1
Head 3
Outfit 1 & 6
Upper Body 1
Lower Body 3
Wings 1

↑ **Platform Boots**
Accessory 1
Head 2
Outfit 5
Upper Body 2
Lower Body 4
Wings 4

Gothic 3

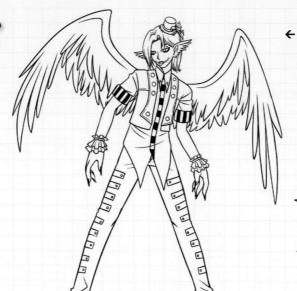

← Stripes
Head 4
Outfit 4
Upper Body 2
Lower Body 2
Wings 2

Layers

⬛	Accessory 1
	Accessory 2
⬛	Accessory 3
	Accessory 4
	Outfit 1
	Outfit 2
	Outfit 3
	Outfit 4
	Outfit 5
	Outfit 6
	Head 1
	Head 2
	Head 3
	Head 4
	Upper Body 1
	Upper Body 2
	Upper Body 3
	Lower Body 1
	Lower Body 2
	Lower Body 3
	Lower Body 4
	Wings 1
	Wings 2
	Wings 3
	Wings 4

↑ Batty
Accessory 3 & 4
Head 3
Outfit 1
Upper Body 3
Lower Body 4
Wings 3

← Dandy
Head 4
Outfit 3
Upper Body 1
Lower Body 4
Wings 1

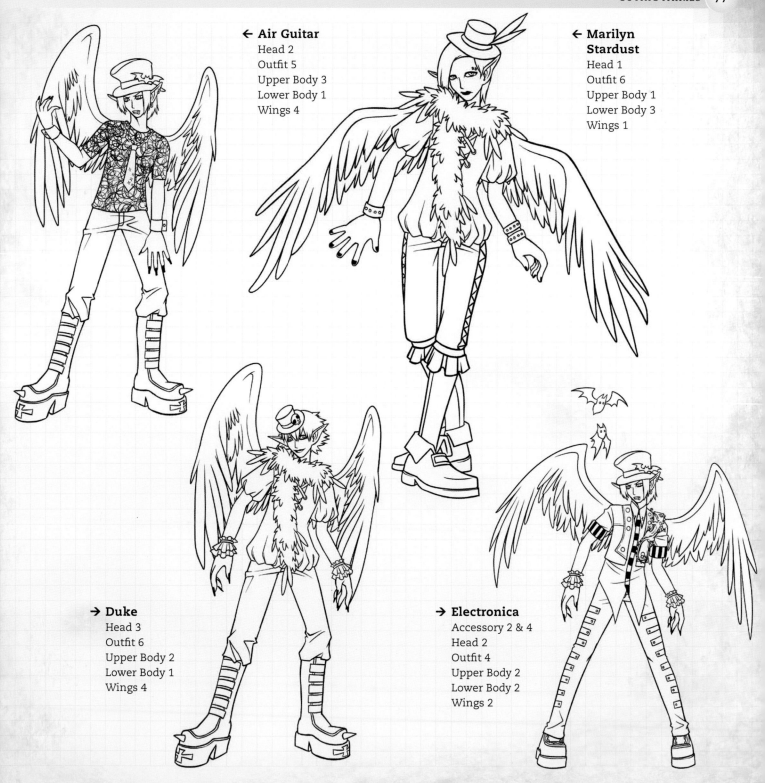

← **Air Guitar**
Head 2
Outfit 5
Upper Body 3
Lower Body 1
Wings 4

← **Marilyn Stardust**
Head 1
Outfit 6
Upper Body 1
Lower Body 3
Wings 1

→ **Duke**
Head 3
Outfit 6
Upper Body 2
Lower Body 1
Wings 4

→ **Electronica**
Accessory 2 & 4
Head 2
Outfit 4
Upper Body 2
Lower Body 2
Wings 2

Puck Fairies

MERRY WANDERER OF THE NIGHT

A puck fairy is a hobgoblin character and a renowned prankster, with powers of shapeshifting. Human follies are his perpetual entertainment. He has been seen as a hobbit, or has changed into an eagle, ass, or horse, but whilst many writers have referred to this solitary, faun-faced, trickster (Ben Jonson, John Milton, Goethe, Rudyard Kipling) it is the Puck of Shakespeare's *A Midsummer Night's Dream* that has popularized a mischievous, but friendly fairy—an often shaggy spirit among more delicate fairies. Puck is one of many that make up the Fairy court.

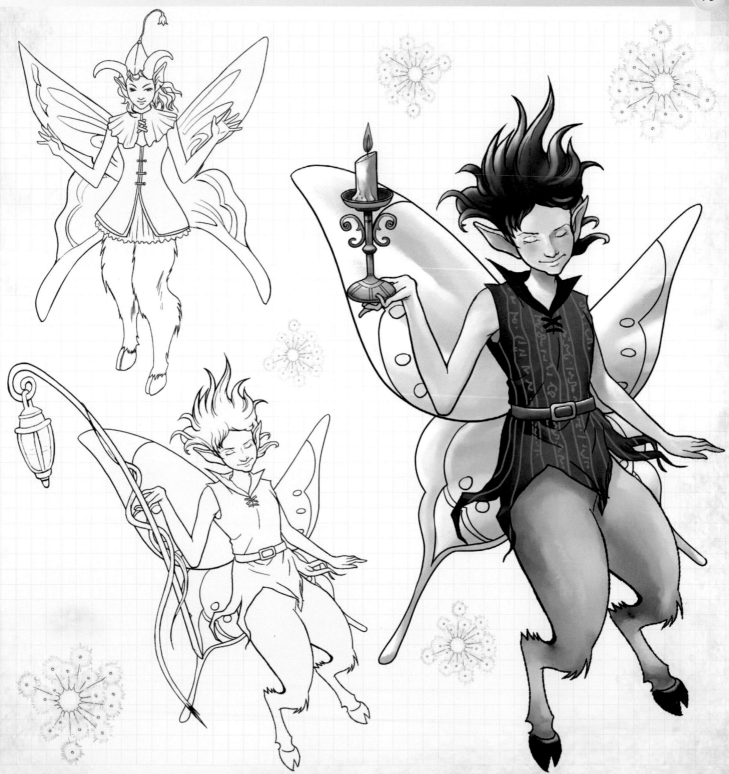

Puck 1

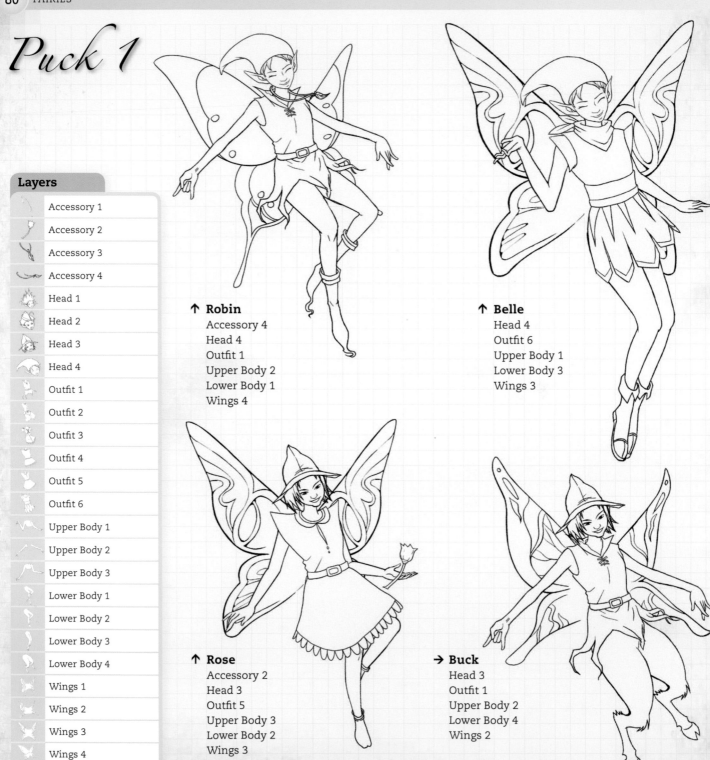

Layers

- Accessory 1
- Accessory 2
- Accessory 3
- Accessory 4
- Head 1
- Head 2
- Head 3
- Head 4
- Outfit 1
- Outfit 2
- Outfit 3
- Outfit 4
- Outfit 5
- Outfit 6
- Upper Body 1
- Upper Body 2
- Upper Body 3
- Lower Body 1
- Lower Body 2
- Lower Body 3
- Lower Body 4
- Wings 1
- Wings 2
- Wings 3
- Wings 4

↑ **Robin**
Accessory 4
Head 4
Outfit 1
Upper Body 2
Lower Body 1
Wings 4

↑ **Belle**
Head 4
Outfit 6
Upper Body 1
Lower Body 3
Wings 3

↑ **Rose**
Accessory 2
Head 3
Outfit 5
Upper Body 3
Lower Body 2
Wings 3

→ **Buck**
Head 3
Outfit 1
Upper Body 2
Lower Body 4
Wings 2

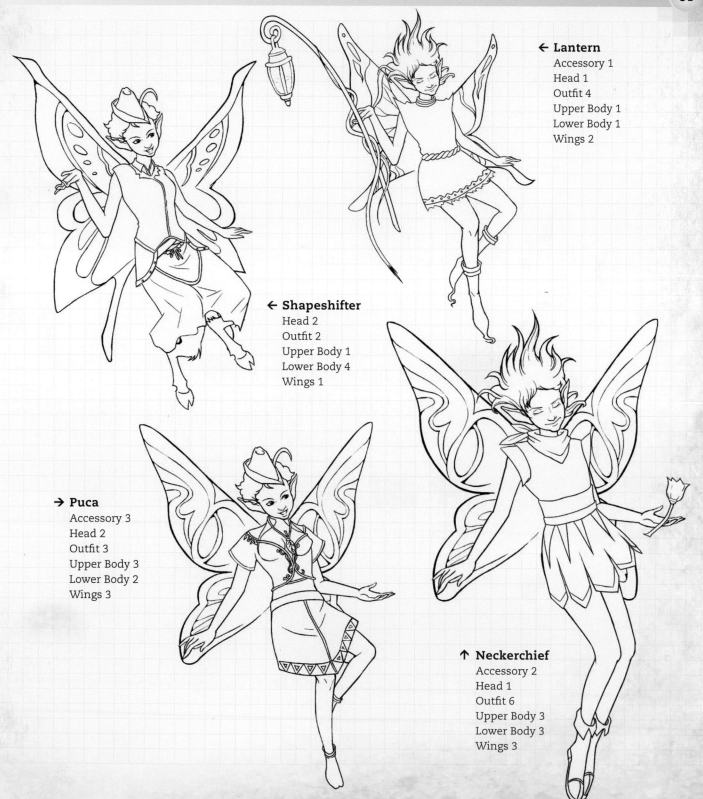

← **Lantern**
Accessory 1
Head 1
Outfit 4
Upper Body 1
Lower Body 1
Wings 2

← **Shapeshifter**
Head 2
Outfit 2
Upper Body 1
Lower Body 4
Wings 1

→ **Puca**
Accessory 3
Head 2
Outfit 3
Upper Body 3
Lower Body 2
Wings 3

↑ **Neckerchief**
Accessory 2
Head 1
Outfit 6
Upper Body 3
Lower Body 3
Wings 3

Puck 2

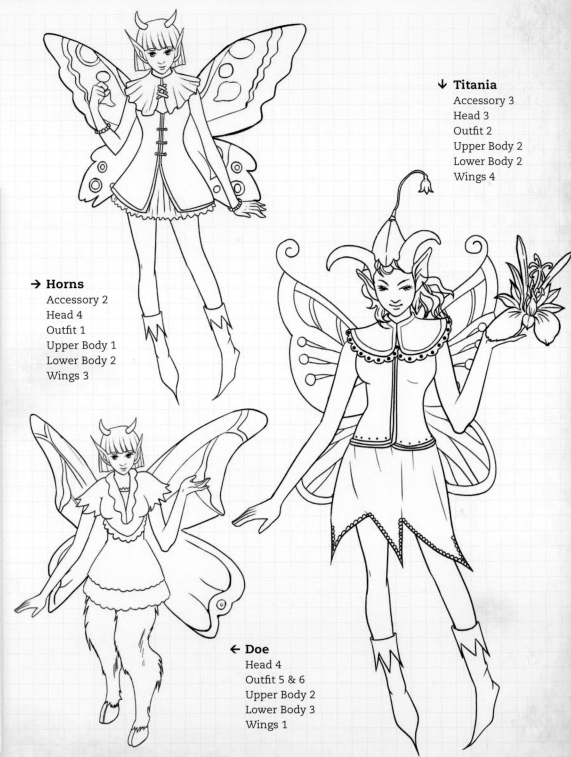

Layers

- Accessory 1
- Accessory 2
- Accessory 3
- Accessory 4
- Head 1
- Head 2
- Head 3
- Head 4
- Outfit 1
- Outfit 2
- Outfit 3
- Outfit 4
- Outfit 5
- Outfit 6
- Outfit 7
- Upper Body 1
- Upper Body 2
- Upper Body 3
- Lower Body 1
- Lower Body 2
- Lower Body 3
- Wings 1
- Wings 2
- Wings 3
- Wings 4

↓ Titania
Accessory 3
Head 3
Outfit 2
Upper Body 2
Lower Body 2
Wings 4

→ Horns
Accessory 2
Head 4
Outfit 1
Upper Body 1
Lower Body 2
Wings 3

← Doe
Head 4
Outfit 5 & 6
Upper Body 2
Lower Body 3
Wings 1

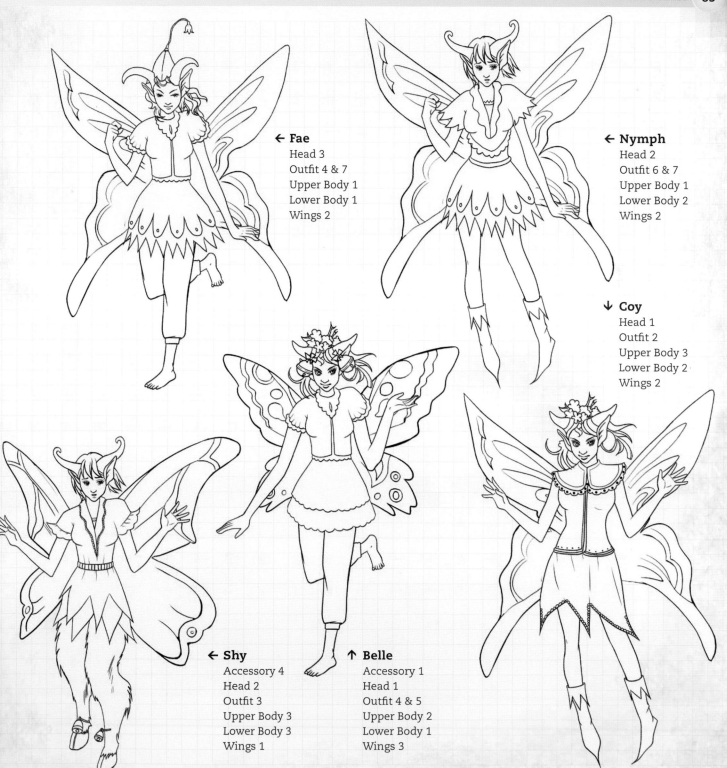

← **Fae**
Head 3
Outfit 4 & 7
Upper Body 1
Lower Body 1
Wings 2

← **Nymph**
Head 2
Outfit 6 & 7
Upper Body 1
Lower Body 2
Wings 2

↓ **Coy**
Head 1
Outfit 2
Upper Body 3
Lower Body 2
Wings 2

← **Shy**
Accessory 4
Head 2
Outfit 3
Upper Body 3
Lower Body 3
Wings 1

↑ **Belle**
Accessory 1
Head 1
Outfit 4 & 5
Upper Body 2
Lower Body 1
Wings 3

Puck 3

Layers

 Accessory 1

 Accessory 2

 Accessory 3

 Accessory 4

 Accessory 5

 Head 1

 Head 2

 Head 3

 Head 4

 Outfit 1

Outfit 2

Outfit 3

Outfit 4

Outfit 5

Outfit 6

Upper Body 1

Upper Body 2

Upper Body 3

Lower Body 1

Lower Body 2

Lower Body 3

Lower Body 4

Wings 1

Wings 2

Wings 3

Wings 4

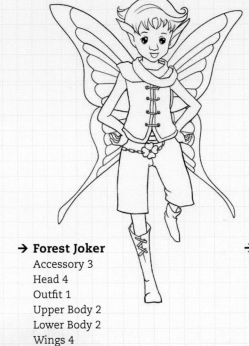

→ Forest Joker
Accessory 3
Head 4
Outfit 1
Upper Body 2
Lower Body 2
Wings 4

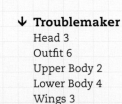

→ Fooling Around
Head 4
Outfit 2
Upper Body 1
Lower Body 1
Wings 3

↓ Troublemaker
Head 3
Outfit 6
Upper Body 2
Lower Body 4
Wings 3

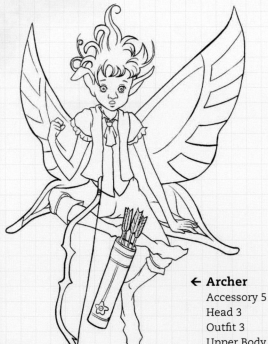

← Archer
Accessory 5
Head 3
Outfit 3
Upper Body 3
Lower Body 3
Wings 2

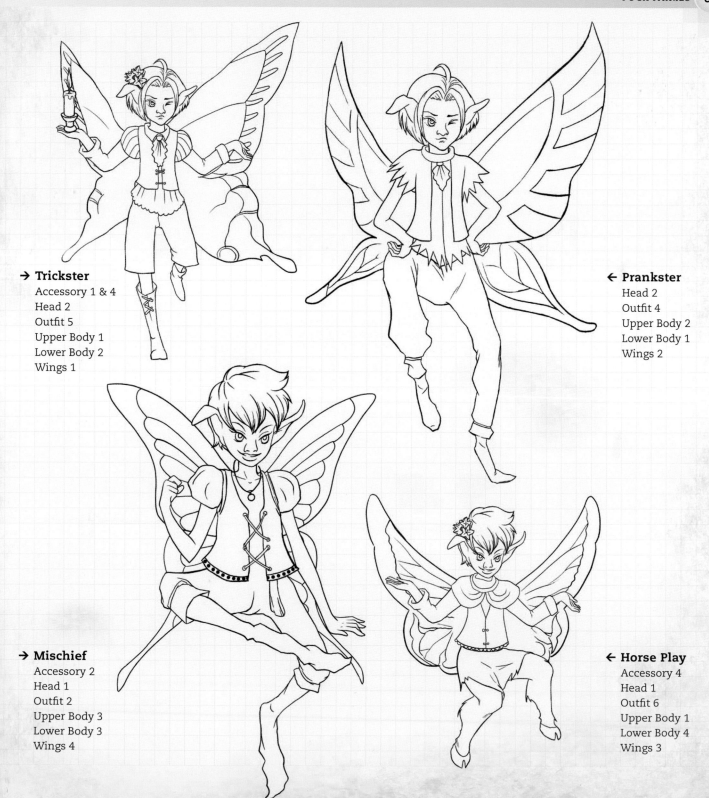

→ Trickster
Accessory 1 & 4
Head 2
Outfit 5
Upper Body 1
Lower Body 2
Wings 1

← Prankster
Head 2
Outfit 4
Upper Body 2
Lower Body 1
Wings 2

→ Mischief
Accessory 2
Head 1
Outfit 2
Upper Body 3
Lower Body 3
Wings 4

← Horse Play
Accessory 4
Head 1
Outfit 6
Upper Body 1
Lower Body 4
Wings 3

Garden Fairies

SPIRITS OF THE EARTH

Garden fairies have their roots based in the Victorian era, when artists romanticized the world of the fairy with flowers, blossoms, and frills. Poets, composers, playwrights, and prolific artists of the time depicted fairies rioting with insects like butterflies, caterpillars, and bumblebees in their fairy worlds. Garden fairies represent all the elements—air, earth, fire, and water—as well as the seasons. They remind us to appreciate the beauty of our natural world.

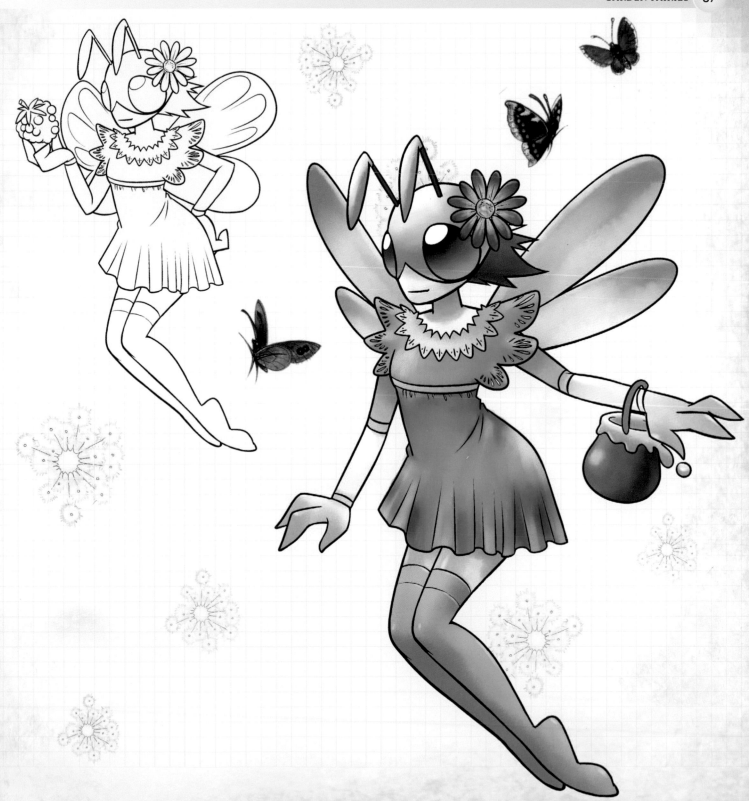

Fruit Fairy

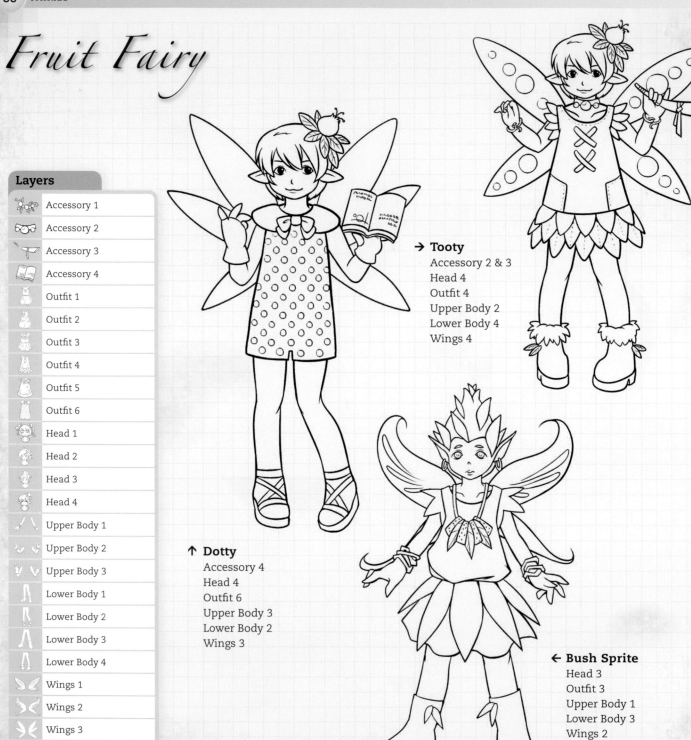

Layers

	Accessory 1
	Accessory 2
	Accessory 3
	Accessory 4
	Outfit 1
	Outfit 2
	Outfit 3
	Outfit 4
	Outfit 5
	Outfit 6
	Head 1
	Head 2
	Head 3
	Head 4
	Upper Body 1
	Upper Body 2
	Upper Body 3
	Lower Body 1
	Lower Body 2
	Lower Body 3
	Lower Body 4
	Wings 1
	Wings 2
	Wings 3
	Wings 4

➜ **Tooty**
Accessory 2 & 3
Head 4
Outfit 4
Upper Body 2
Lower Body 4
Wings 4

↑ **Dotty**
Accessory 4
Head 4
Outfit 6
Upper Body 3
Lower Body 2
Wings 3

← **Bush Sprite**
Head 3
Outfit 3
Upper Body 1
Lower Body 3
Wings 2

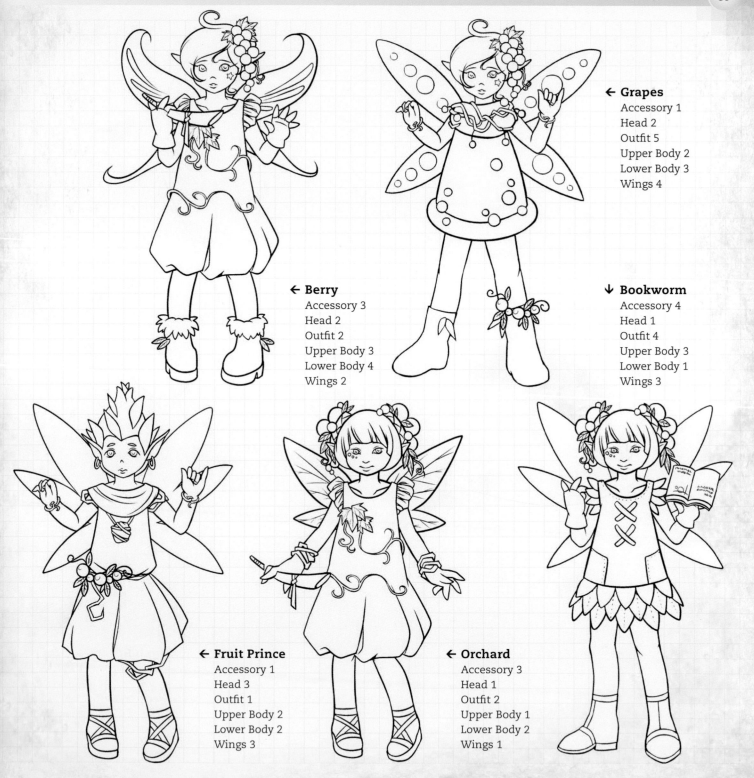

← **Berry**
Accessory 3
Head 2
Outfit 2
Upper Body 3
Lower Body 4
Wings 2

← **Grapes**
Accessory 1
Head 2
Outfit 5
Upper Body 2
Lower Body 3
Wings 4

↓ **Bookworm**
Accessory 4
Head 1
Outfit 4
Upper Body 3
Lower Body 1
Wings 3

← **Fruit Prince**
Accessory 1
Head 3
Outfit 1
Upper Body 2
Lower Body 2
Wings 3

← **Orchard**
Accessory 3
Head 1
Outfit 2
Upper Body 1
Lower Body 2
Wings 1

Garden Fairy

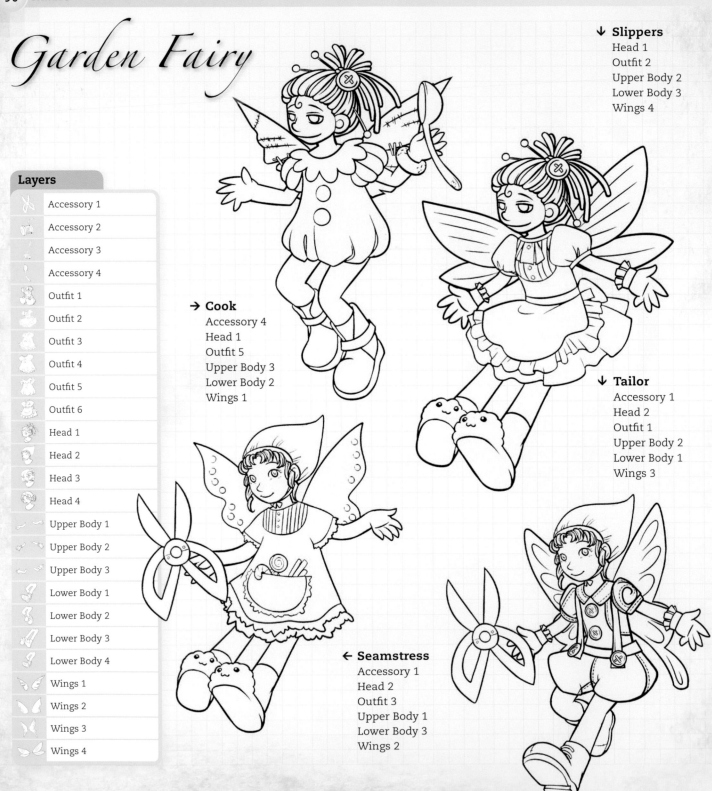

Layers

	Accessory 1
	Accessory 2
	Accessory 3
	Accessory 4
	Outfit 1
	Outfit 2
	Outfit 3
	Outfit 4
	Outfit 5
	Outfit 6
	Head 1
	Head 2
	Head 3
	Head 4
	Upper Body 1
	Upper Body 2
	Upper Body 3
	Lower Body 1
	Lower Body 2
	Lower Body 3
	Lower Body 4
	Wings 1
	Wings 2
	Wings 3
	Wings 4

↓ **Slippers**
Head 1
Outfit 2
Upper Body 2
Lower Body 3
Wings 4

→ **Cook**
Accessory 4
Head 1
Outfit 5
Upper Body 3
Lower Body 2
Wings 1

↓ **Tailor**
Accessory 1
Head 2
Outfit 1
Upper Body 2
Lower Body 1
Wings 3

← **Seamstress**
Accessory 1
Head 2
Outfit 3
Upper Body 1
Lower Body 3
Wings 2

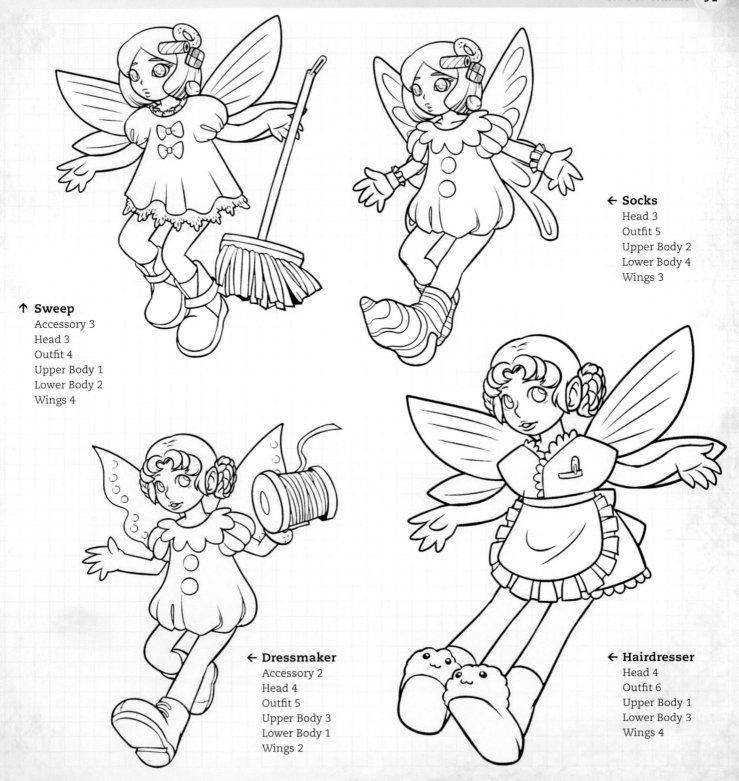

↑ Sweep
Accessory 3
Head 3
Outfit 4
Upper Body 1
Lower Body 2
Wings 4

← Socks
Head 3
Outfit 5
Upper Body 2
Lower Body 4
Wings 3

← Dressmaker
Accessory 2
Head 4
Outfit 5
Upper Body 3
Lower Body 1
Wings 2

← Hairdresser
Head 4
Outfit 6
Upper Body 1
Lower Body 3
Wings 4

Insect Fairy

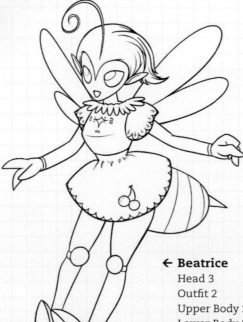

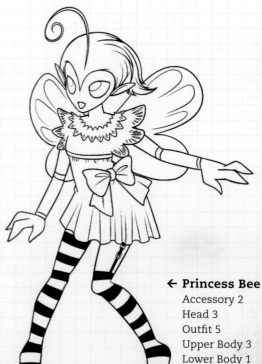

Layers

 Accessory 1

 Accessory 2

 Accessory 3

 Accessory 4

 Outfit 1

 Outfit 2

 Outfit 3

 Outfit 4

 Outfit 5

 Outfit 6

 Head 1

 Head 2

Head 3

Head 4

 Upper Body 1

Upper Body 2

Upper Body 3

Lower Body 1

 Lower Body 2

Lower Body 3

Lower Body 4

 Wings 1

 Wings 2

 Wings 3

Wings 4

→ **Daisy**
Accessory 1
Head 2
Outfit 4
Upper Body 1
Lower Body 3
Wings 3

← **Wasp Fairy**
Head 1
Outfit 1
Upper Body 2
Lower Body 2
Wings 2

← **Beatrice**
Head 3
Outfit 2
Upper Body 2
Lower Body 2
Wings 2

← **Princess Bee**
Accessory 2
Head 3
Outfit 5
Upper Body 3
Lower Body 1
Wings 1

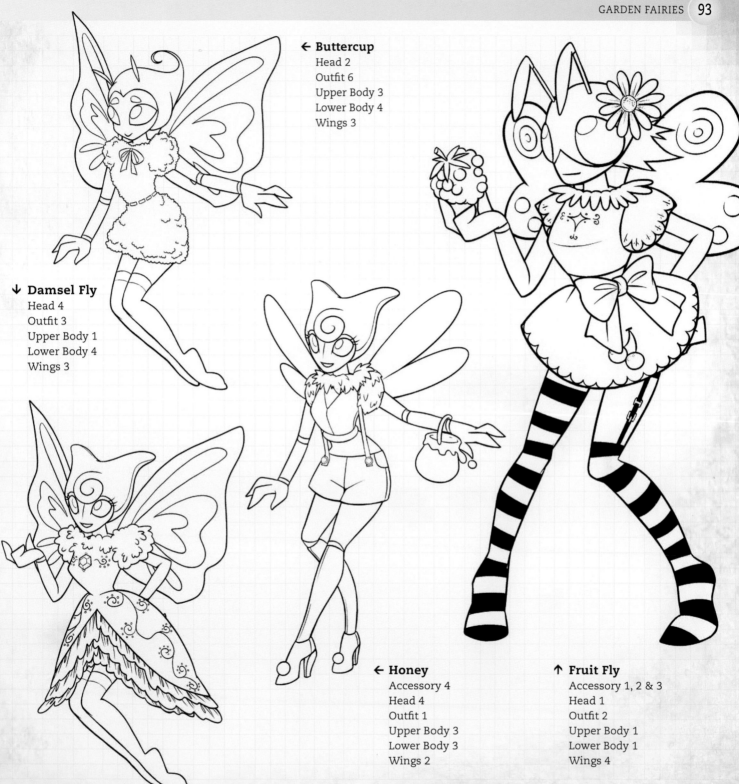

← Buttercup
Head 2
Outfit 6
Upper Body 3
Lower Body 4
Wings 3

↓ Damsel Fly
Head 4
Outfit 3
Upper Body 1
Lower Body 4
Wings 3

← Honey
Accessory 4
Head 4
Outfit 1
Upper Body 3
Lower Body 3
Wings 2

↑ Fruit Fly
Accessory 1, 2 & 3
Head 1
Outfit 2
Upper Body 1
Lower Body 1
Wings 4

Woodland Folk

CREATURES OF THE UNDERGROWTH

Woodlands are alive with all sorts of creatures, but finding or seeing fairies is another thing. You are more likely to find their sentries; shrews, dormice, and frogs, and other little creatures hiding in the undergrowth among the moss and leaves. This is the world of elves, pixies, goblins, trolls, gnomes, and other little people.

Woodland Folk 1

Layers

	Accessory 1
	Accessory 2
	Accessory 3
	Accessory 4
	Head 1
	Head 2
	Head 3
	Head 4
	Outfit 1
	Outfit 2
	Outfit 3
	Outfit 4
	Outfit 5
	Outfit 6
	Upper Body 1
	Upper Body 2
	Upper Body 3
	Lower Body 1
	Lower Body 2
	Lower Body 3
	Lower Body 4
	Wings 1
	Wings 2
	Wings 3
	Wings 4

← Razor
Head 2
Outfit 6
Upper Body 3
Lower Body 2
Wings 2

← Shrew
Accessory 1 & 3
Head 4
Outfit 3
Upper Body 1
Lower Body 1
Wings 3

← Ratty
Accessory 3
Head 1
Outfit 3
Upper Body 3
Lower Body 4
Wings 4

↑ Mouse
Accessory 2
Head 1
Outfit 5
Upper Body 2
Lower Body 1
Wings 1

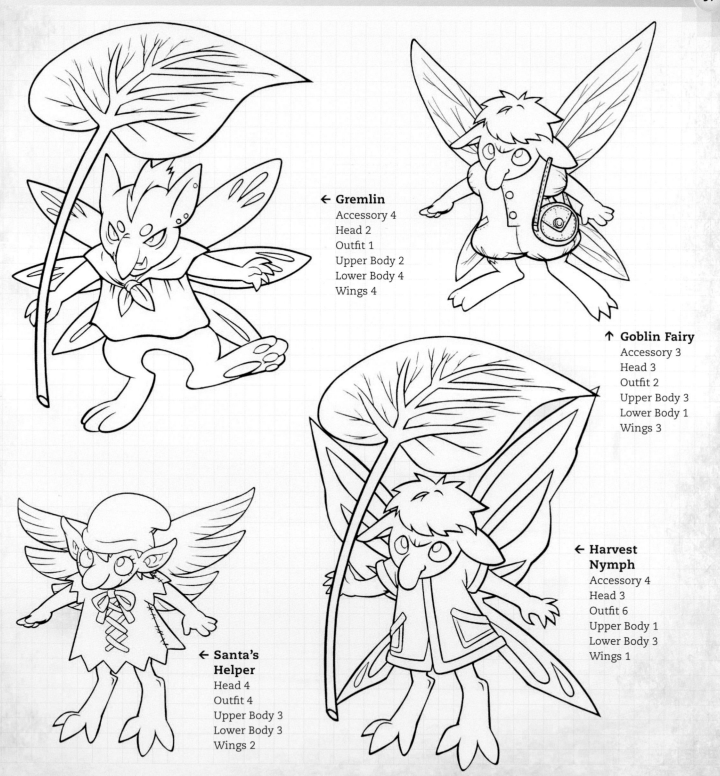

← **Gremlin**
Accessory 4
Head 2
Outfit 1
Upper Body 2
Lower Body 4
Wings 4

↑ **Goblin Fairy**
Accessory 3
Head 3
Outfit 2
Upper Body 3
Lower Body 1
Wings 3

← **Santa's Helper**
Head 4
Outfit 4
Upper Body 3
Lower Body 3
Wings 2

← **Harvest Nymph**
Accessory 4
Head 3
Outfit 6
Upper Body 1
Lower Body 3
Wings 1

Woodland Folk 2

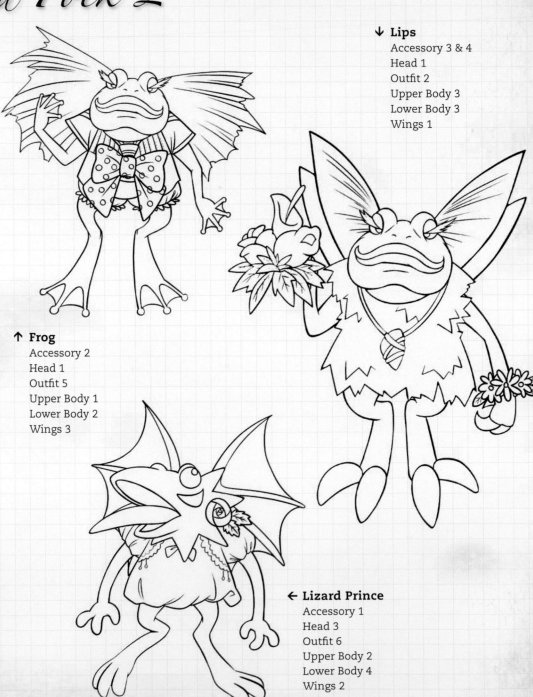

Layers

- Accessory 1
- Accessory 2
- Accessory 3
- Accessory 4
- Head 1
- Head 2
- Head 3
- Head 4
- Outfit 1
- Outfit 2
- Outfit 3
- Outfit 4
- Outfit 5
- Outfit 6
- Upper Body 1
- Upper Body 2
- Upper Body 3
- Lower Body 1
- Lower Body 2
- Lower Body 3
- Lower Body 4
- Wings 1
- Wings 2
- Wings 3
- Wings 4

↓ **Lips**
Accessory 3 & 4
Head 1
Outfit 2
Upper Body 3
Lower Body 3
Wings 1

↑ **Frog**
Accessory 2
Head 1
Outfit 5
Upper Body 1
Lower Body 2
Wings 3

← **Lizard Prince**
Accessory 1
Head 3
Outfit 6
Upper Body 2
Lower Body 4
Wings 2

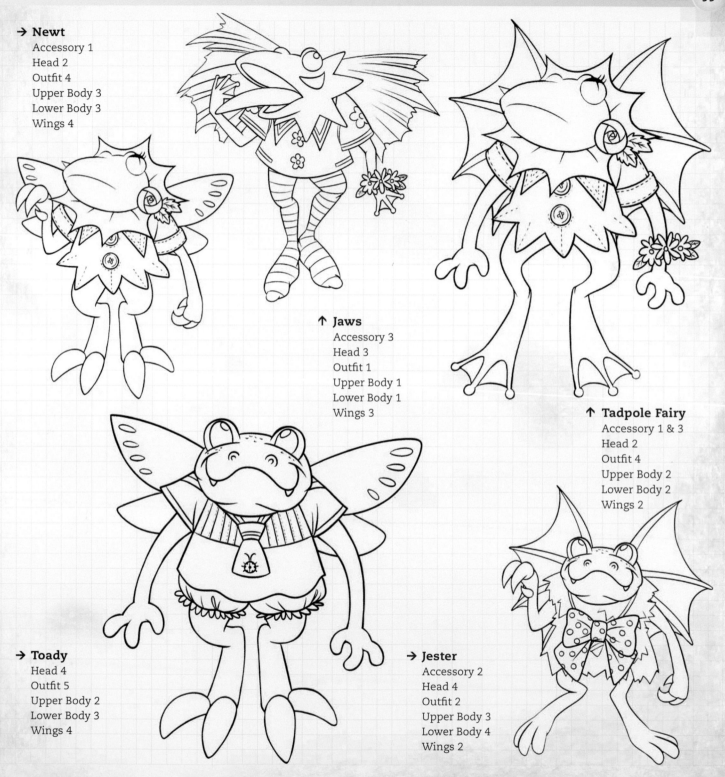

→ **Newt**
Accessory 1
Head 2
Outfit 4
Upper Body 3
Lower Body 3
Wings 4

↑ **Jaws**
Accessory 3
Head 3
Outfit 1
Upper Body 1
Lower Body 1
Wings 3

↑ **Tadpole Fairy**
Accessory 1 & 3
Head 2
Outfit 4
Upper Body 2
Lower Body 2
Wings 2

→ **Toady**
Head 4
Outfit 5
Upper Body 2
Lower Body 3
Wings 4

→ **Jester**
Accessory 2
Head 4
Outfit 2
Upper Body 3
Lower Body 4
Wings 2

Woodland Folk 3

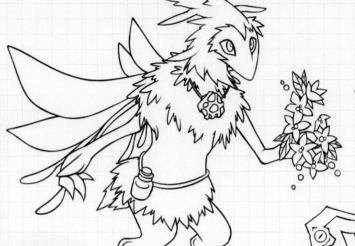

Layers

Accessory 1
Accessory 2
Accessory 3
Accessory 4
Head 1
Head 2
Head 3
Head 4
Outfit 1
Outfit 2
Outfit 3
Outfit 4
Outfit 5
Outfit 6
Upper Body 1
Upper Body 2
Upper Body 3
Lower Body 1
Lower Body 2
Lower Body 3
Lower Body 4
Wings 1
Wings 2
Wings 3
Wings 4

← Gatekeeper
Accessory 2 & 4
Head 1
Outfit 6
Upper Body 1
Lower Body 2
Wings 2

↓ Tree Sprite
Accessory 3
Head 2
Outfit 1
Upper Body 1
Lower Body 3
Wings 1

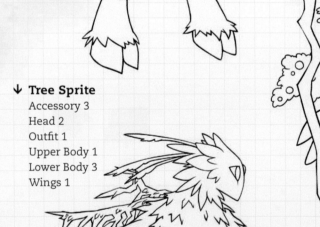

↑ Herder
Accessory 1
Head 1
Outfit 5
Upper Body 2
Lower Body 1
Wings 4

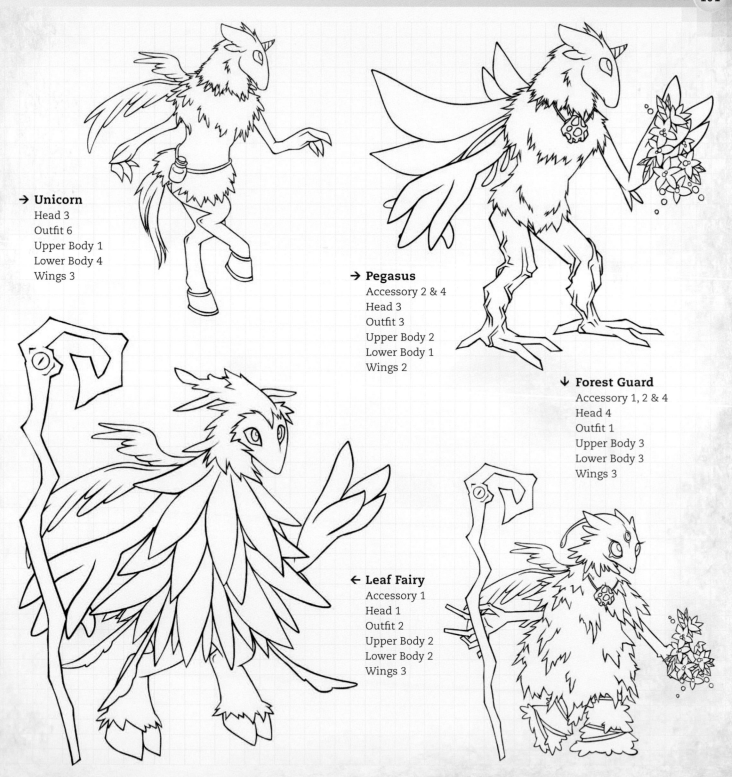

→ **Unicorn**
Head 3
Outfit 6
Upper Body 1
Lower Body 4
Wings 3

→ **Pegasus**
Accessory 2 & 4
Head 3
Outfit 3
Upper Body 2
Lower Body 1
Wings 2

↓ **Forest Guard**
Accessory 1, 2 & 4
Head 4
Outfit 1
Upper Body 3
Lower Body 3
Wings 3

← **Leaf Fairy**
Accessory 1
Head 1
Outfit 2
Upper Body 2
Lower Body 2
Wings 3

Elves, Pixies, and Gnomes

FOLKLORE'S FAIRY COMPANIONS

European folklore abounds with mythological creatures. Britain has its pixies, best known as "piskies" in Devon and Cornwall, which mostly have pointed ears, often wear green, and care for the forest and its trees. Gnomes, who love to make jewelry with fine gems, are earth elementals that live in trees on green rolling hills and in rocky woodlands, and care for the countryside and wildlife. Elves are from Northern Europe, Iceland, Scandinavia, and Germany. Myths have portrayed them to be long-lived or immortal, and as beings of magical powers. Elves were originally thought of as a race of minor nature and fertility gods—beings of great beauty that live in forests.

Elves

Layers

- Accessory 1
- Accessory 2
- Accessory 3
- Accessory 4
- Accessory 5
- Accessory 6
- Head 1
- Head 2
- Head 3
- Head 4
- Outfit 1
- Outfit 2
- Outfit 3
- Outfit 4
- Outfit 5_1
- Outfit 5_2
- Outfit 6
- Upper Body 1
- Upper Body 2
- Upper Body 3
- Lower Body 1
- Lower Body 2
- Lower Body 3
- Accessory 7
- Accessory 8
- Accessory 9
- Accessory 10

↑ **Chuckles**
Accessory 2, 3, 4,
7, 9 & 10
Head 4
Outfit 2
Upper Body 3
Lower Body 1

↑ **Elvis**
Accessory 2, 6 & 8
Head 4
Outfit 3
Upper Body 2
Lower Body 2

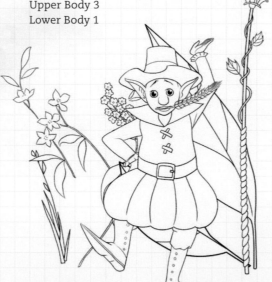

↑ **River Dance**
Accessory 2, 5, 8,
9 & 10
Head 1
Outfit 5_1 & 5_2
Upper Body 1
Lower Body 1

→ **Jolly**
Accessory 1, 2, 3,
4, 6, 9 & 10
Head 1
Outfit 2
Upper Body 2
Lower Body 2

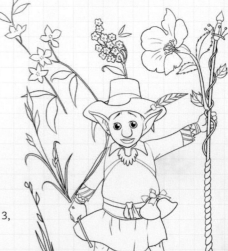

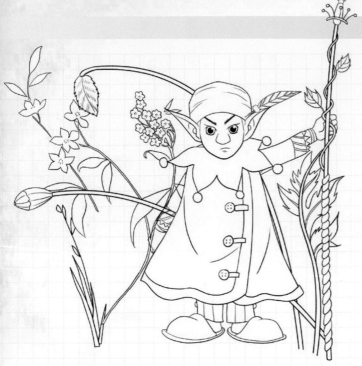

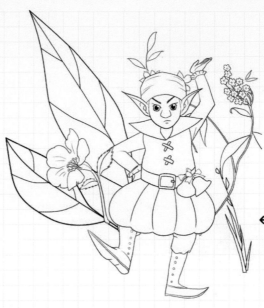

← Fury
Accessory 1, 4, 8,
9 & 10
Head 2
Outfit 5_1 & 5_2
Upper Body 1
Lower Body 1

↑ Angry
Accessory 2, 6, 7,
9 & 10
Head 2
Outfit 6
Upper Body 2
Lower Body 3

→ Surprised
Accessory 1, 3, 4
8 & 10
Head 3
Outfit 1
Upper Body 3
Lower Body 3

← Sprite
Accessory 1, 3, 6,
7 & 10
Head 3
Outfit 4
Upper Body 2
Lower Body 2

Pixies

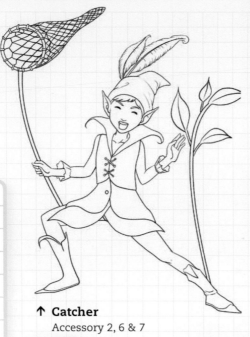

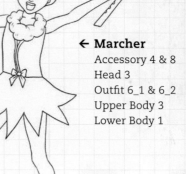

Layers

	Accessory 1
	Accessory 2
	Accessory 3
	Accessory 4
	Head 1
	Head 2
	Head 3
	Head 4
	Outfit 1
	Outfit 2
	Outfit 3
	Outfit 4
	Outfit 5
	Outfit 6_1
	Outfit 6_2
	Upper Body 1
	Upper Body 2
	Upper Body 3
	Lower Body 1
	Lower Body 2
	Lower Body 3
	Accessory 5
	Accessory 6
	Accessory 7
	Accessory 8

↑ Catcher
Accessory 2, 6 & 7
Head 3
Outfit 1
Upper Body 2
Lower Body 3

← Marcher
Accessory 4 & 8
Head 3
Outfit 6_1 & 6_2
Upper Body 3
Lower Body 1

↓ Yoga
Accessory 1, 3 & 5
Head 2
Outfit 3
Upper Body 2
Lower Body 2

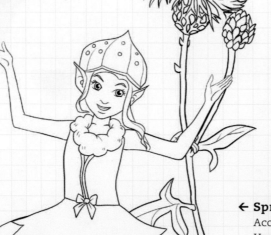

← Springer
Accessory 8
Head 2
Outfit 6_1 & 6_2
Upper Body 1
Lower Body 3

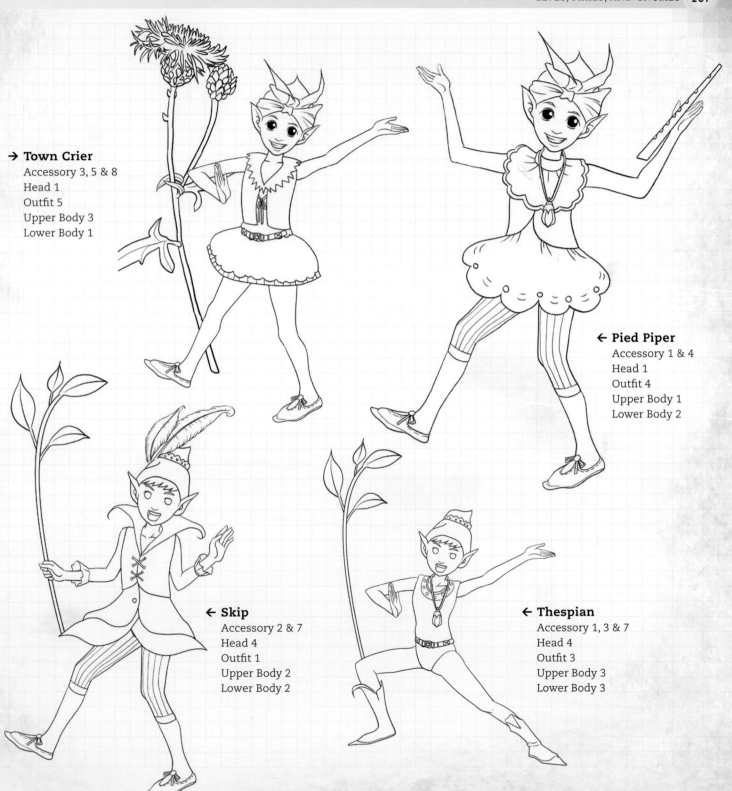

→ Town Crier
Accessory 3, 5 & 8
Head 1
Outfit 5
Upper Body 3
Lower Body 1

← Pied Piper
Accessory 1 & 4
Head 1
Outfit 4
Upper Body 1
Lower Body 2

← Skip
Accessory 2 & 7
Head 4
Outfit 1
Upper Body 2
Lower Body 2

← Thespian
Accessory 1, 3 & 7
Head 4
Outfit 3
Upper Body 3
Lower Body 3

Gnomes

Layers

- Accessory 1
- Accessory 2
- Accessory 3
- Accessory 4
- Head 1
- Head 2
- Head 3
- Head 4
- Outfit 1
- Outfit 2
- Outfit 3
- Outfit 4
- Outfit 5
- Outfit 6
- Upper Body 1
- Upper Body 2
- Upper Body 3
- Lower Body 1
- Lower Body 2
- Lower Body 3
- Accessory 5
- Accessory 6
- Accessory 7
- Accessory 8

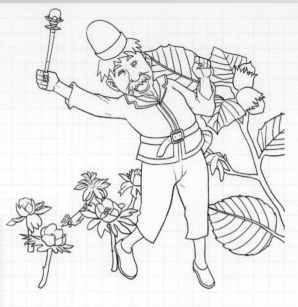

↓ **Happy**
Accessory 2 & 6
Head 4
Outfit 1
Upper Body 2
Lower Body 2

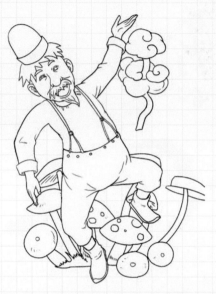

↑ **Bonkers**
Accessory 4, 5 & 8
Head 4
Outfit 2
Upper Body 1
Lower Body 1

↓ **Grumpy**
Accessory 4 & 7
Head 3
Outfit 5
Upper Body 1
Lower Body 2

→ **Dumpy**
Accessory 3, 5 & 8
Head 3
Outfit 3
Upper Body 2
Lower Body 3

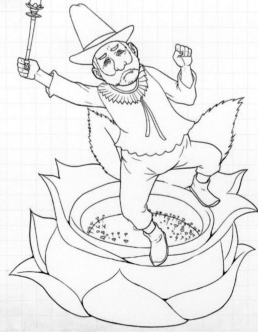

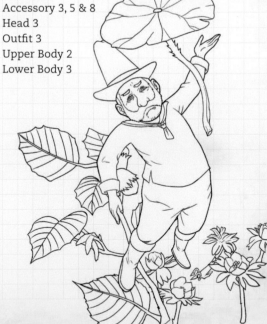

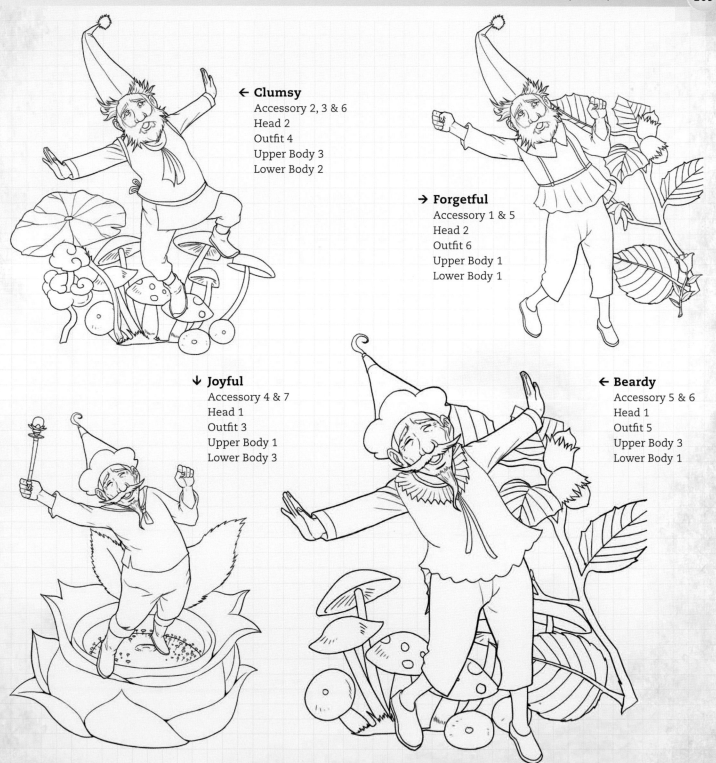

← **Clumsy**
Accessory 2, 3 & 6
Head 2
Outfit 4
Upper Body 3
Lower Body 2

→ **Forgetful**
Accessory 1 & 5
Head 2
Outfit 6
Upper Body 1
Lower Body 1

↓ **Joyful**
Accessory 4 & 7
Head 1
Outfit 3
Upper Body 1
Lower Body 3

← **Beardy**
Accessory 5 & 6
Head 1
Outfit 5
Upper Body 3
Lower Body 1

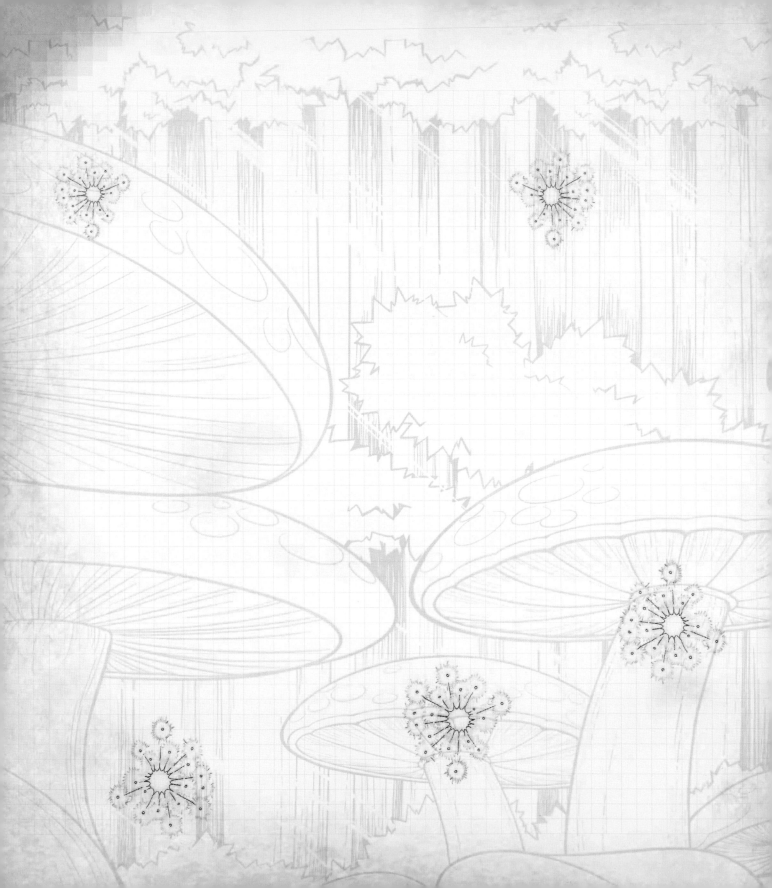

Backgrounds

Fairy art is not just about the sprites themselves, but the enchanting worlds in which they inhabit. Here are eight backdrops to set your fairy artwork against, from far away fantasy castles to lush forest mushroom patches.

Backgrounds

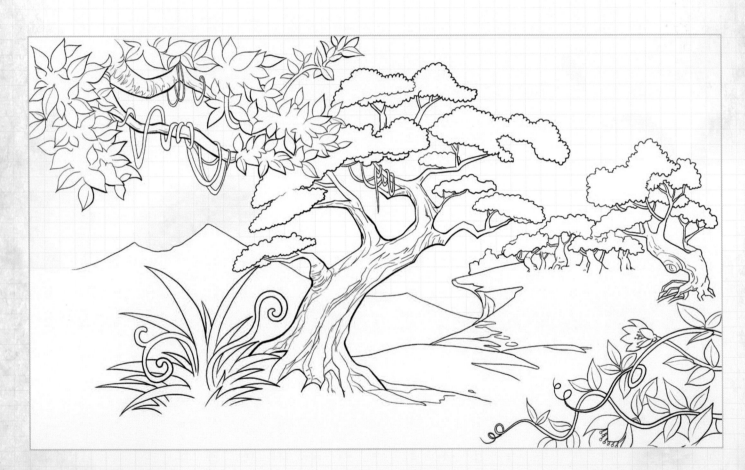

Background 1: Forest Glade
An open clearing for fairies to gather, where sylphs can perform their dainty dances and mischievous pucks can stage their pranks.

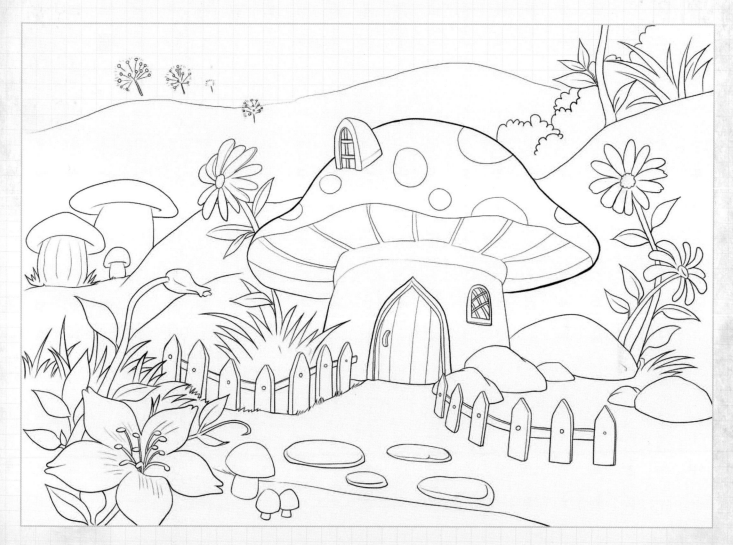

Background 2: Toadstool Hut
The traditional home for fairies, gnomes, elves, and pixies alike.

Backgrounds

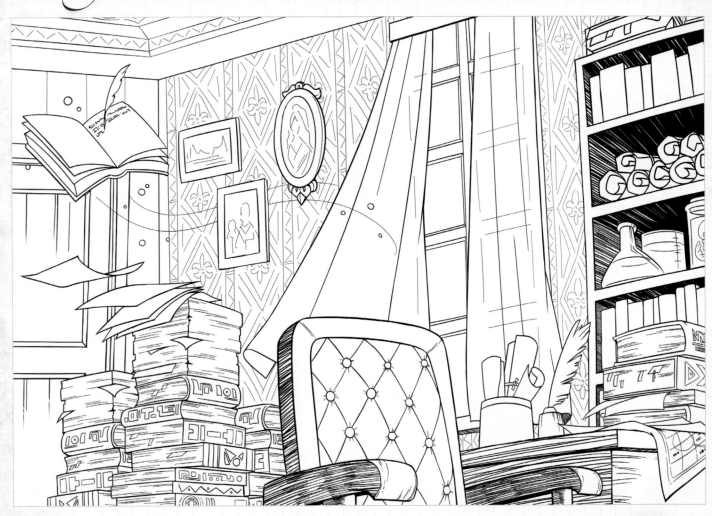

Background 3: Magic Library
A gold mine of ancient spells and tales of wonder. Be careful where your fairies sit!

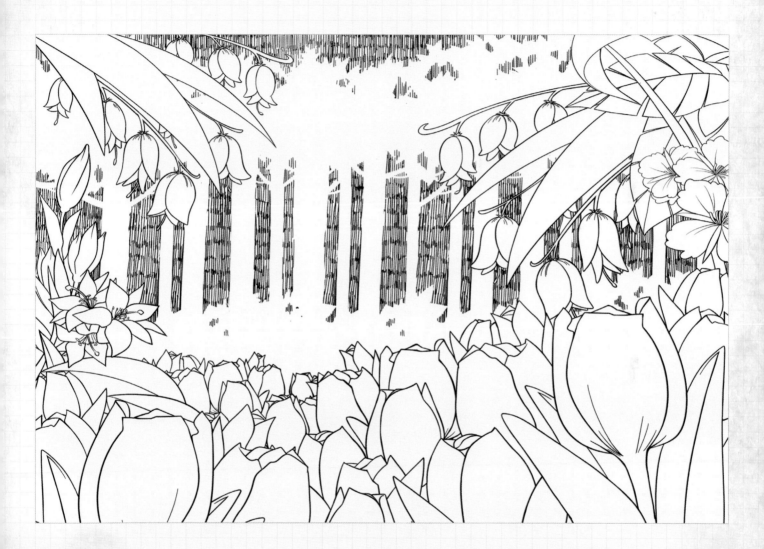

Background 4: Tulip Patch
Thriving tulips along the
forest floor—there must
be flower fairies about!

Backgrounds

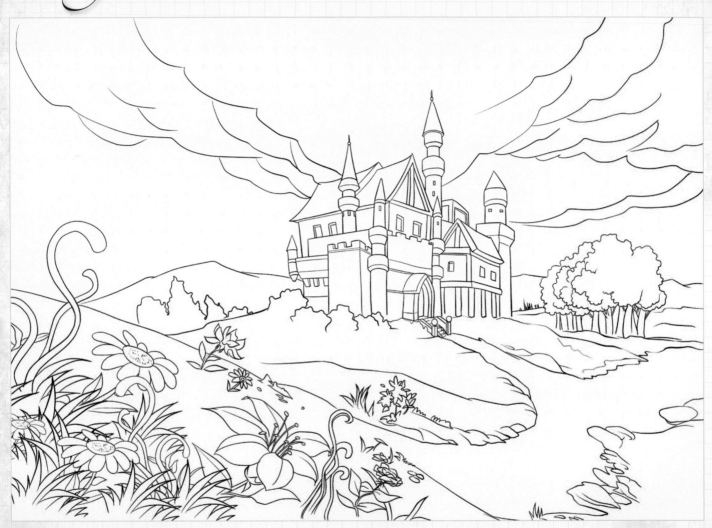

Background 5: Fantasy Castle
An ancient castle; a safe haven for fairies. Depending on how the sky is colored, it could be a beautiful summers day—or those could be looming thunderclouds up there!

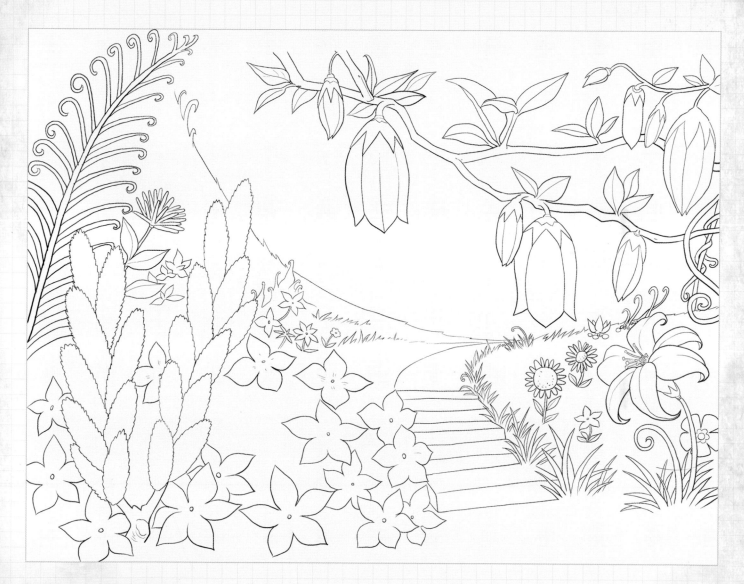

Background 6: Secret Stairway
Tucked away in the forest, among the overgrowth lies a hidden staircase—an entry to a magical realm?

Backgrounds

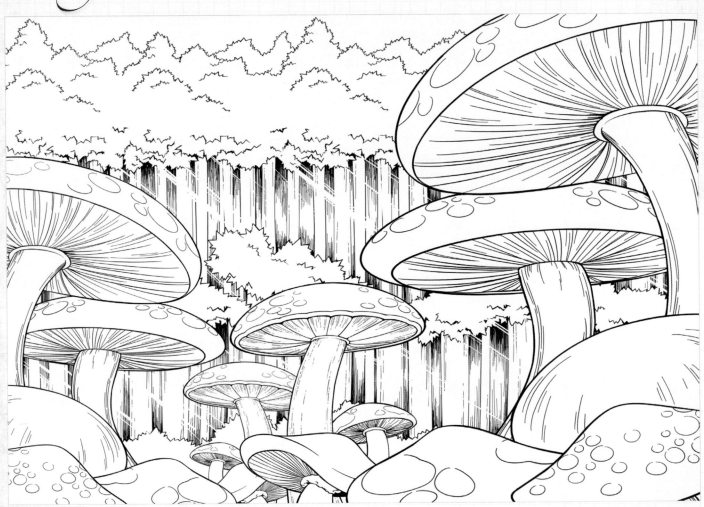

Background 7: Mushroom Glade
A hotspot for fairy activity where
you'll find all sorts of folk, and most
likely gnomes, pixies, and elves.

Background 8: Woodland Clearing
A quiet spot deep in the woods, or
a setting for pucks up to no good?

Accessories, plants, and flowers

A selection of accessories, plants, and flowers have been included to complement your fairy artwork; different types of fauna and flora, and, of course, tools of the magical trade.

Accessories

As described earlier in the book, on pages 26–27, you can customize your fairies by adding accessories. Choose from musical instruments, Victorian-inspired ornaments, and animal friends to add context to your pictures.

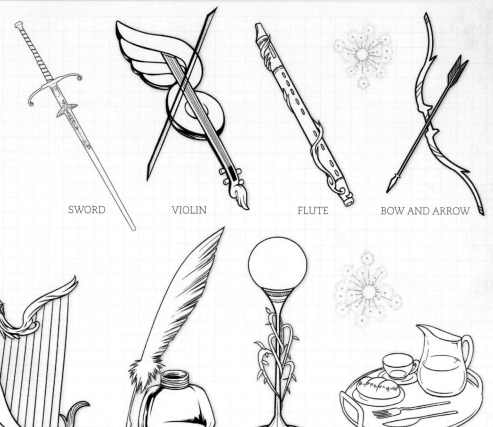

SWORD VIOLIN FLUTE BOW AND ARROW

BUTTERFLY HARP INK AND QUILL CRYSTAL BALL BREAKFAST SET

CROWN CLOCK LAMP CANDLE GLASS COMB

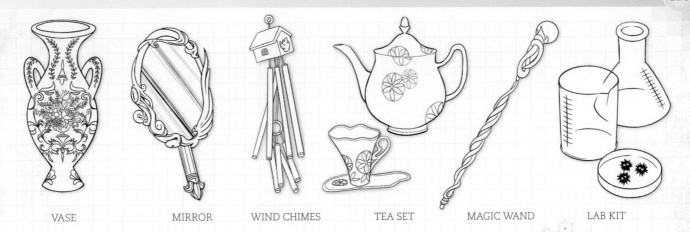

VASE MIRROR WIND CHIMES TEA SET MAGIC WAND LAB KIT

OWL BAT RABBIT SWAN BIRD

RECORD PLAYER SEWING KIT SPELL BOOK PICTURE

Plants and Flowers

Using the Free Transform options described on page 25, you can resize, rotate, and flip these plants and flowers to complement your fairy scene. Hide your fairy among tall grass reeds, or place a delicate rose in a pixie's palm.

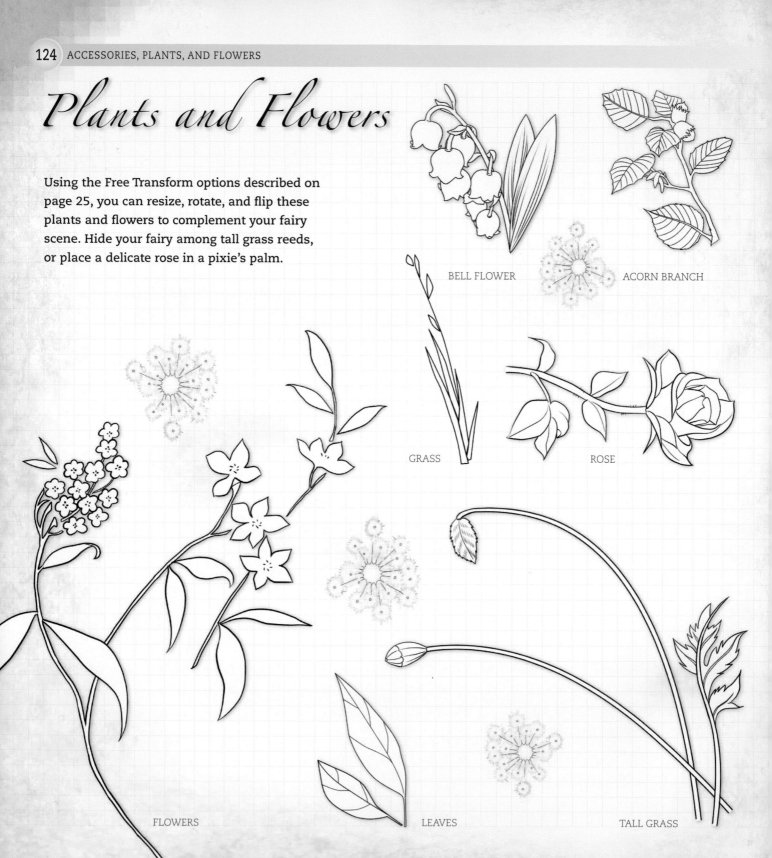

BELL FLOWER

ACORN BRANCH

GRASS

ROSE

FLOWERS

LEAVES

TALL GRASS

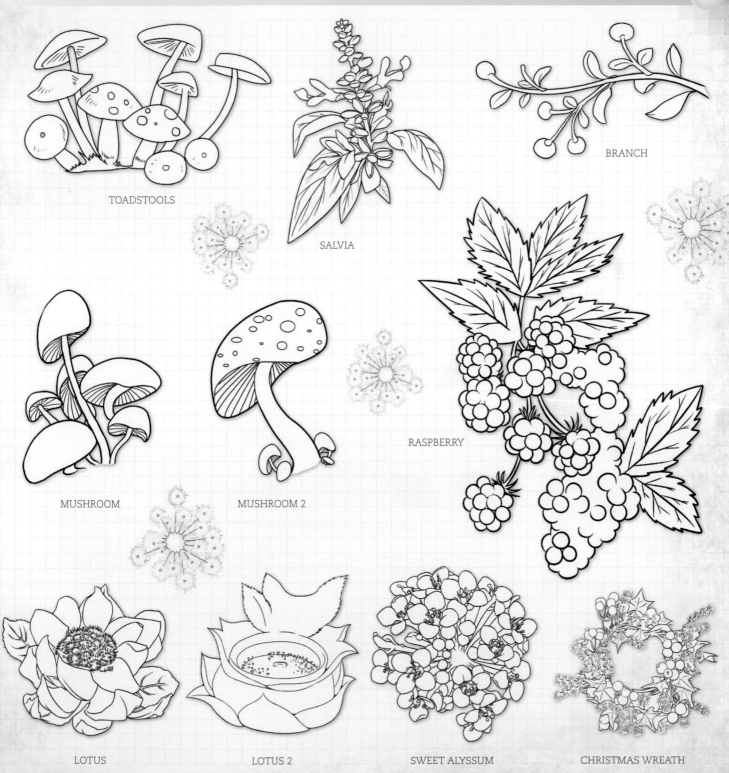

TOADSTOOLS

SALVIA

BRANCH

MUSHROOM

MUSHROOM 2

RASPBERRY

LOTUS

LOTUS 2

SWEET ALYSSUM

CHRISTMAS WREATH

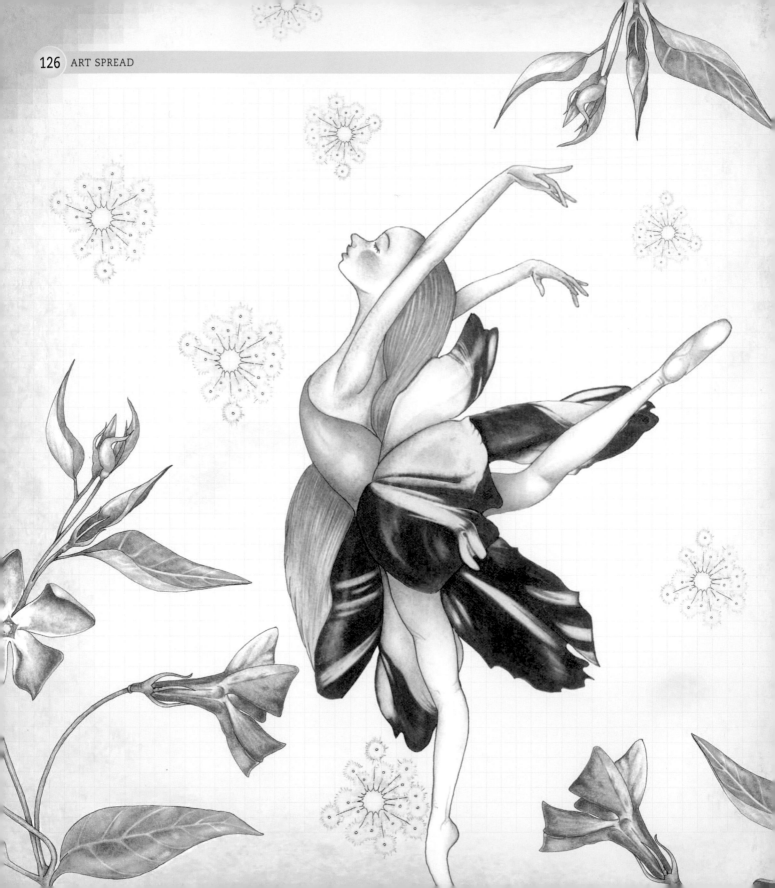

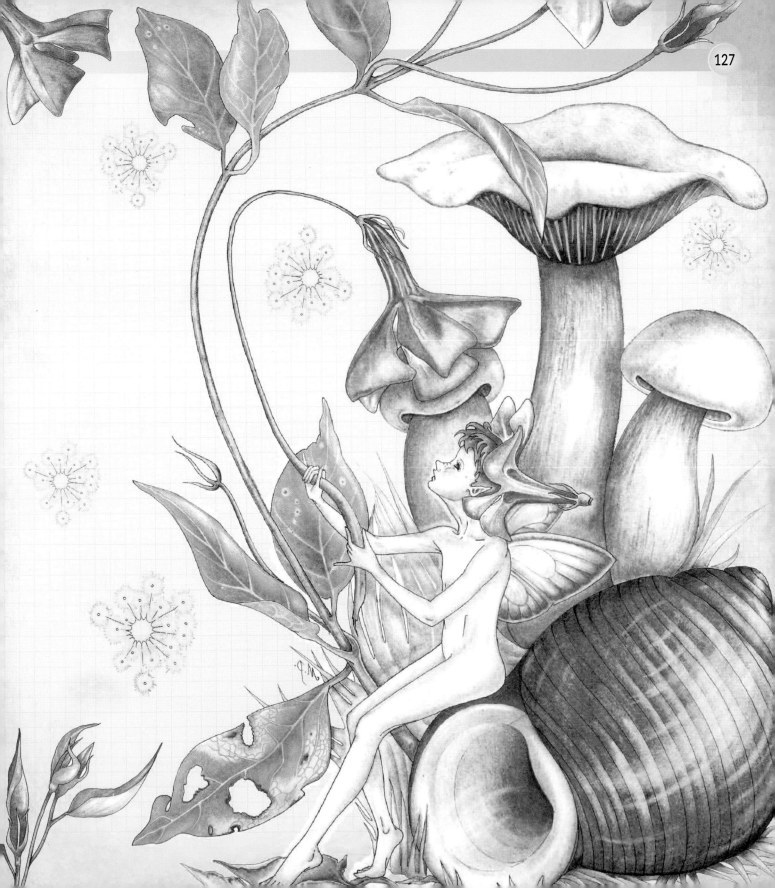

Index